IMAGES
of America

KINGMAN

Dan W. Messersmith

ARCADIA
PUBLISHING

Published by Arcadia Publishing
Charleston, South Carolina

Printed in the United States of America

Library of Congress Control Number: 2010924355

For all general information contact Arcadia Publishing at:
Telephone 843-853-2070
Fax 843-853-0044
E-mail sales@arcadiapublishing.com
For customer service and orders:
Toll-Free 1-888-313-2665

Visit us on the Internet at www.arcadiapublishing.com

This work is dedicated to the board of directors of the Mohave County Historical Society and their long-term efforts to preserve the history and story of what was and is Mohave County, Arizona.

CONTENTS

ACKNOWLEDGMENTS

I wish to acknowledge the efforts of several of the volunteers and staff that make the Mohave Museum of History and Arts a research facility second to none. Its extensive library and archives and dedicated volunteers and staff make it a benchmark for museums three times its size. I want to thank the people listed below.

Pat Foley, for helping me sort through and select the many photographs that were used in preparation for the book. His expertise in handling the vast collection of photographs in the digital archives is remarkable.

Chuck Cox, for his knowledge of the Kingman area and expertise in managing the content of the photographs. It has been an absolute pleasure to work with him in this endeavor, and I have learned a great deal from him.

Andy Sansom, for his insight and humor along the way as we discussed, as a group, the various photographs during the selection and dating processes, and for his assistance with a number of Internet searches to refine some details.

Shannon Rossiter, for his leadership of the museum as its director and his assistance when I needed to access the fragile printed items in the archives to sort out a question of fact. Always there and supportive, his assistance is greatly appreciated.

A special acknowledgement goes to Kay Ellerman, the museum's librarian, for her untiring effort in helping me sort out the details of photograph after photograph with search after search of files, books, and publications when looking for that one more piece of information I just had to have. Thank you, Kay. I could not have found all that I needed without your help, and this book could not have been completed without your assistance.

All of the photographs used in this work, unless otherwise credited, are courtesy of the Mohave Museum of History and Arts in Kingman, Arizona.

INTRODUCTION

The photographic history presented in this work is just a small sample of what is readily available through the archives of the Mohave Museum of History and Arts and represents just a glimpse of the fascinating past of our community. Over 700 images were selected and reviewed to come up with the 206 in this book, and during the many hours of work to put this together, much was learned that was unknown to me prior to the project. Some of what was "known" was challenged and had to be corrected. Frequently photographs provided as many questions as answers and required a great deal of follow-up research to resolve. I have made my best attempt to give the readers a span of information and photographs that give a feel for how Kingman looked in its earlier years. It has been a task to eliminate any of the images, as each tells its own story. Space available, however, is a finite feature of any book. So every effort has been made to include some of the best and most interesting. I believe the end product not only provides the reader with a fascinating look back at the Kingman that was, but also a better insight on what Kingman can become.

Numerous photographs are of properties on Front and South Front Streets. Front Street is now known as Andy Devine Avenue, and South Front Street is now Topeka Street. The first entry in any given chapter will identify that distinction, but it will not be repeated in every photograph.

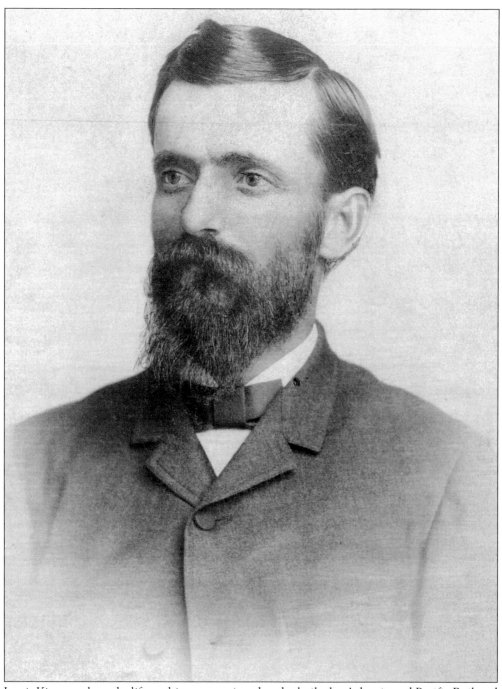

Lewis Kingman brought life to this community when he built the Atlantic and Pacific Railroad across northern Arizona. Kingman had a long and successful career in railroad construction in both the United States and Mexico. The photograph of Kingman dates from 1883, during the time of the railroad construction through Arizona. (Courtesy of the Mohave Museum of History and Arts.)

One

The Railroad and Kingman's Begininnings

Without the Atchison, Topeka and Santa Fe Railway (AT&SF), Kingman might have never existed. It was the coming of the railroad that fully opened up the surrounding mining communities. Prior to inexpensive rail transportation, freight costs meant that only the highest quality ore could be shipped. The railway also helped the cattle industry, since for the first time ranchers could make direct shipments of cattle or sheep to market.

Because of the railroad, mining and ranching would flourish, and Kingman would be the main recipient of the economic impact. Along with the commercial growth would come a growing political base that would soon have the votes to move the seat of county government from Mineral Park to Kingman. The railroad was Kingman's creator, heart, and lifeblood. The town's economic and political development was tied to the rails, creating a bond that continues in the present-day community.

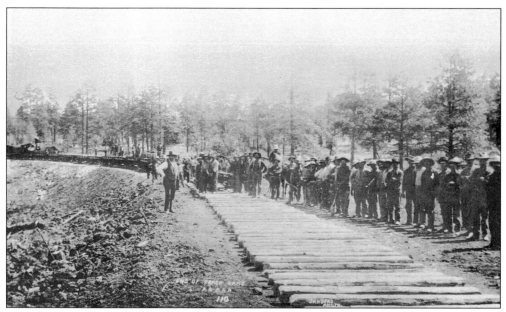

This 1882 scene is at end-of-track in the building of the Atlantic and Pacific Railroad, a subsidiary of the AT&SF, across the 35th parallel route in territorial Arizona. These crews, led by chief engineer Lewis Kingman, provided endless stories and conjecture on the exact route and where the sidings would be placed. Fortunes were to be made by correct speculation. (Courtesy Santa Fe Railway.)

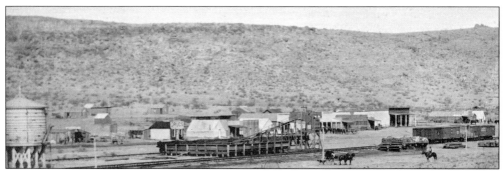

By 1883 to 1884, the new Kingman siding had started to grow. According to 1883 tax rolls (which reflect 1882 information), Kingman included one tent used as a restaurant, one tent used as a residence, a lumber house known as Ryan's and Lassel's Saloon, a hotel run by B. H. Spear, and a stable and corral with one horse. It can be truly said that Kingman was once a one-horse town!

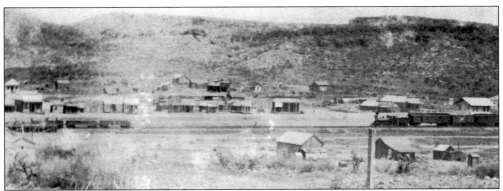

This c. 1885 view of Kingman reflects its continued growth as a mining supply center. The train sits in front of the new Atlantic and Pacific Railroad station on the far right. The station was located at the southeast corner of Fourth and Front (Andy Devine Avenue) Streets. The intersection of Fourth and Front Streets would become the heart of downtown Kingman. The *Mohave County Miner* reported in September of 1884: "Kingman is well supplied with business houses; we can now boast of three general merchandise stores, three saloons, three restaurants, one lodging house, one drug store, one blacksmith shop, carpenter shop, sampling works, lumber yard, two livery stables, one butcher shop and two assay offices."

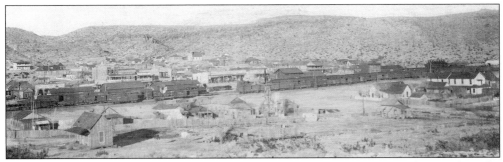

Based on the number of railroad cars and engines as well as the numerous warehouses along the tracks, this c. 1897 photograph provides a feel for Kingman's prosperity. The commercial center of town has become established, and more construction is going on along Front Street. Kingman had been chosen 10 years earlier to be the new county seat. The town's permanent courthouse was opened in 1890 and can be seen in the distance on the far left.

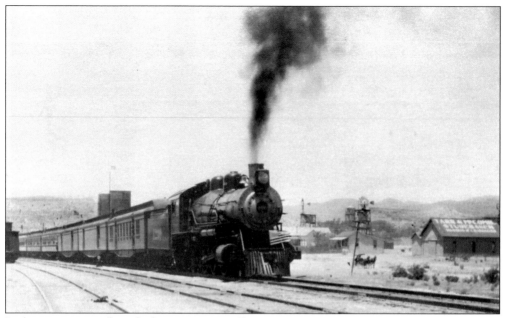

Rail transportation flourished in Kingman. Pulling passenger, express, and freight cars, locomotive 1230, built in 1905, makes its way east out of town. This photograph probably dates from around 1910.

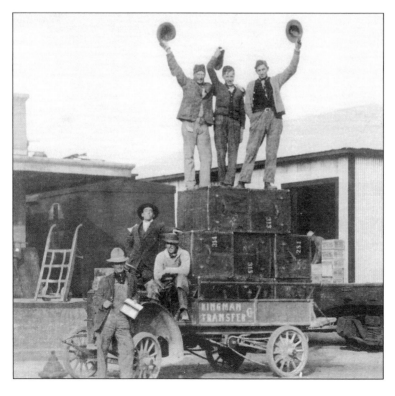

Seated at the wheel of his truck, Summer Beecher, owner of Kingman Transfer Company, poses with his unidentified cronies around 1910. They had just finished picking up a load of freight to be delivered. The man in front of the truck is an unidentified railway depot employee.

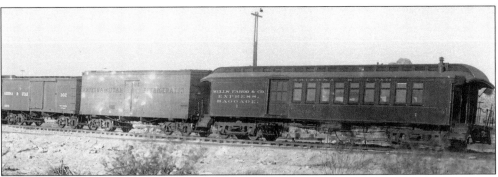

In this *c.* 1910 (or earlier) photograph, cars of the Arizona and Utah (A&U) Railway are stored on a siding. The A&U was a spur line that connected Kingman to Chloride from 1899 to 1933. As the name implies, original plans were for the railroad to continue north, cross the Colorado River, and connect with a rail line in Utah. Those plans never panned out, and tracks went no farther than Chloride, just 20 miles from Kingman. It was locally known as the "Chloride Back and Forth," based on frequent use by citizens to commute between the two towns. The train's primary purpose was to carry freight to the mines in the Chloride area and return with ore. In 1906, the A&U Railway would be reorganized as the Western Arizona Railway, a wholly owned subsidiary of the AT&SF. It continued to run until the mines started to give out in the area it served. The line ceased operation in 1933 and was dissolved in December 1934. The track was taken up for scrap or resale, and the ties were picked up by a local entrepreneur and sold in Kingman for 5¢ each.

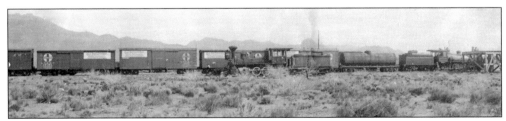

This undated photograph of the A&U Railway shows a train pulling ore cars from the Samoa Mine in the Chloride area. It appears to be stopped at Mineral siding, heading back to Kingman. In front of the freight train, a helper locomotive is stationed at the siding. As most of the cars bear AT&SF logos, this photograph dates to around 1906 or later.

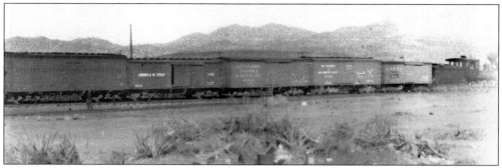

The Western Arizona Railway served the mines of the Cerbat Mountains and Chloride, Arizona. This train contains both A&U and AT&SF cars pulled by No. 46, one of the early A&U locomotives. Because of the older locomotive and mixture of cars, this image probably dates to around 1906.

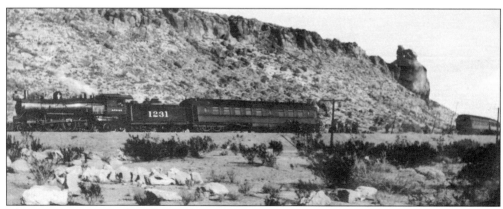

This picture appears to have been taken just west of Kingman in what is known as Railroad Pass. Since locomotive 1231 is the same passenger type as the previously pictured locomotive 1230, this image likely also dates to around 1910. The photograph is credited as being of the A&U Railway, which by 1910 was the Western Arizona Railway. It is probably neither, but one of the regular passenger trains on the AT&SF line. The locomotive was designed (as was No. 1230) to pull larger passenger trains from the West Coast. People are milling around outside the back of the train and down the tracks toward the cars in the background. The reason for this trackside activity is unidentified.

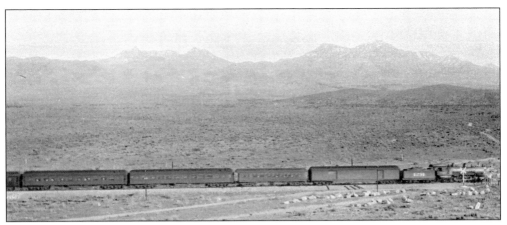

With the Hualapai Mountains in the background, locomotive 1231 pulls a passenger train west through Hualapai Valley toward Kingman around 1910.

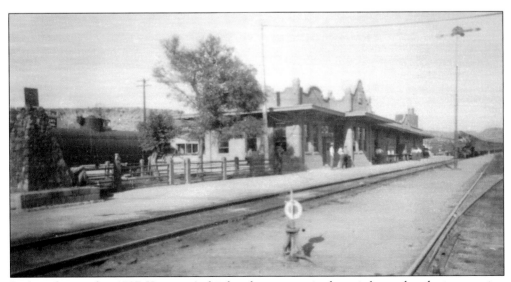

Built and opened in 1907, Kingman's third and current train depot is located at the intersection of Fourth and Front Streets. Two prior depots in the same location burned down: the first in 1900 and the second in 1906. This photograph dates from around 1910.

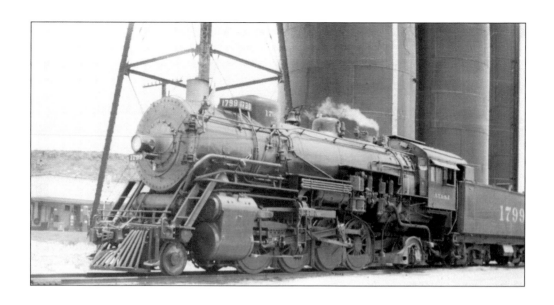

In these *c.* 1930 photographs, locomotives 1799 (above) and 3131 (below), both 2-8-2 types (two engine trucks, eight driver wheels, two trailer wheels) from different locomotive classes, are just two of the many engines that moved people, mail, and freight through Kingman. The 3100 series of locomotives were used many times as "helpers" on eastbound trains to assist in ascending the steep grade of the Arizona Divide near Flagstaff, Arizona. Locomotive 3131 is westbound in the photograph below and may be on its way back to California to "help" another train make the trip.

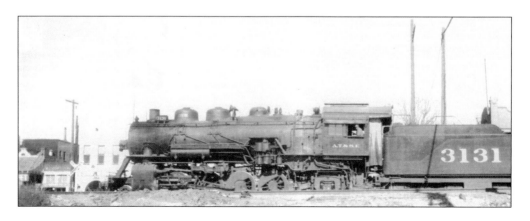

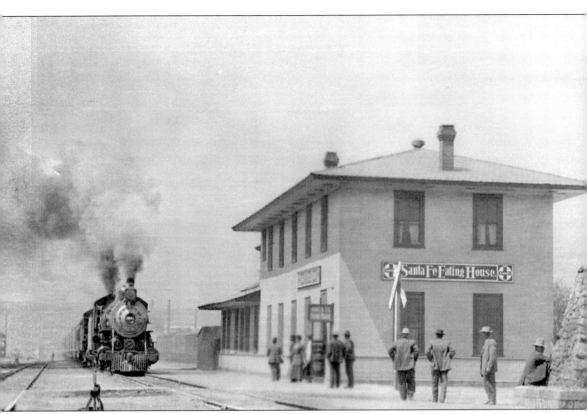

Around 1909 or 1910, an eastbound train pulls into Kingman and eases up toward the Santa Fe Eating House, commonly known as the Harvey House. Construction on the building at the southwest corner of Fourth and Front Streets began in June 1901, and it was open for business on September 1, 1901. In 1912, electric lighting replaced the oil lamps in the building. In August 1917, a 25-foot-wide dining hall was added on the north side. The facility closed in 1932, due to the lack of patrons, but reopened for about six months in 1936, before closing again in December of that year. In 1942, the American Red Cross took over the building and restored it to house soldiers coming in to be stationed at Kingman Army Air Field. In 1943, the facility was turned over to the USO to provide a social and service hall for military men and women stationed in Kingman and those traveling through to other locations. After World War II ended, the American Legion used the building for its meeting hall until a fire gutted it in 1952, and the structure had to be demolished. The stone object at the right is the Ore Monument, made of all of the different mineral-bearing ores found in Mohave County and used to promote mining opportunities in the area.

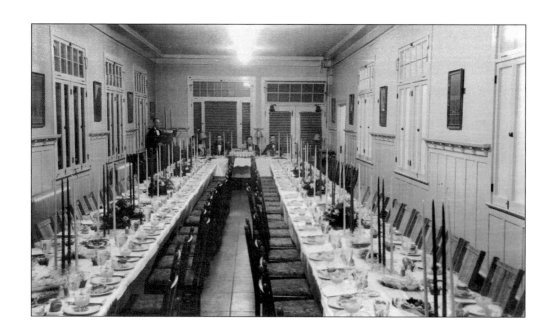

On January 2, 1923, the Harvey House dining room is set up (above) for the Charter Night Banquet of the newly formed Kingman Rotary Club (below). Charter members, all Kingman business and professional men, included R. Levi Anderson, Willis J. Black, Frank E. Boyd, Thomas Devine, Warren G. Damon, Jay M. Gates, Ira M. George, Charles A. Granger, Herbert E. Hart, E. Ross Householder, Smilie S. Jones, J. Harry Knight, Carl G. Krook, Willard L. Linville, John B. Lammers, James W. McElwee, Joseph H. Rosenberg, Charles A. Patterson, Carl J. Walters, Robert W. Wilde, and I. R. (Bud) Waters.

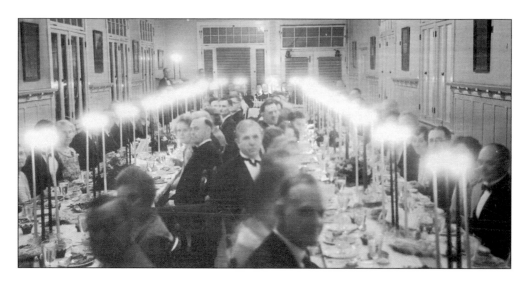

This c. 1927 photograph of the Harvey House shows the single-story, double-door dining room that had been added in 1917.

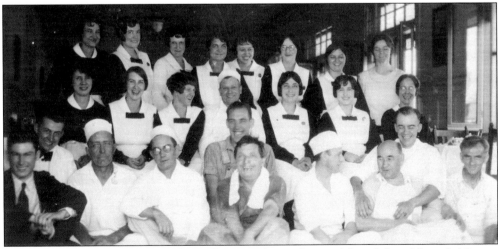

Those identified in the photograph are (first row, first and second from left and far right) Jimmy Galbraith, the newsstand cashier; Frank Matthews; and Walter, vegetable man and pot scrubber; (second row, first and fourth from left) Emily Herron Matthews and a Mr. Rittenhouse, the chef; (third row, third, fourth, and eighth from left) Ora Lee; May Stewart; and Alice McCoy.

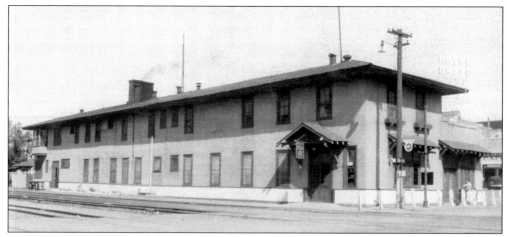

In 1942, the American Red Cross restored the Harvey House, and provides office space for the military while the new Kingman Army Airfield was being constructed. Once office space was available at the airfield, the USO moved in to provide a social and service hall for military men and women stationed in Kingman and those traveling through to other locations.

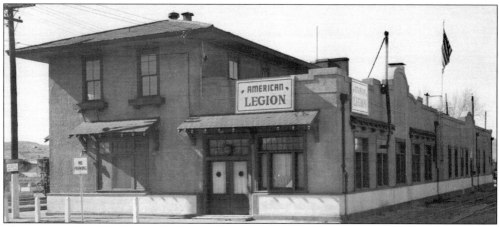

The Harvey House is pictured here around 1950, when it served as the American Legion Hall. The building was gutted by fire in 1952 and had to be demolished.

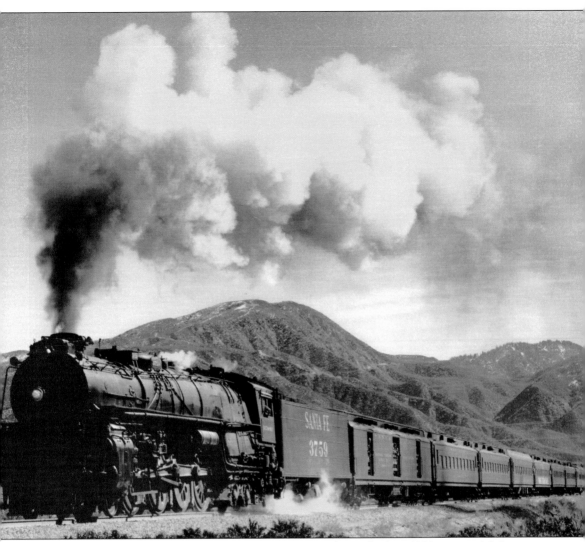

Engine No. 3759, built by the Baldwin Locomotive Works in the late 1920s, was a 4-8-2 type (four engine trucks, eight driver wheels, four trailer wheels) mountain-grade, coal-burning steam locomotive. In 1941, it was refitted to burn oil. One of the large locomotives that served as the main workhorses for passenger traffic in California and Arizona, No. 3759 was capable of reaching speeds of 100 miles per hour. According to Santa Fe records, it travelled 2,585,600 miles during its service years and performed its last run in 1953. Engine 3759 was donated to the City of Kingman, dedicated, and officially presented on August 3, 1957. This photograph is from its "Farewell to Steam" excursion in February 1955.

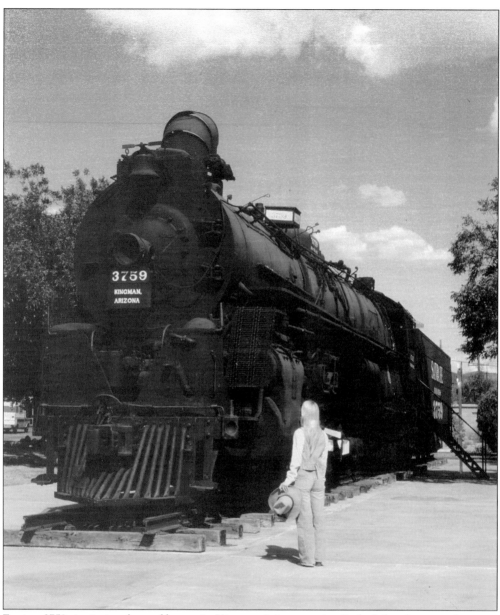

Engine 3759 sits in its place of honor in Kingman's Locomotive Park. It has become the most photographed icon of history in Kingman and truly represents Kingman's birth, history, and prosperity. In the mid-1980s, the community found out that the Santa Fe Railway would be taking all of its cabooses out of service and took action to secure one for the park. The City Parks Department, Downtown Merchants Association, chamber of commerce, Economic and Tourism Development Commission, and untold numbers of citizen volunteers sprang into action. Donations were sought, raffles and fund-raisers were held and souvenir stock certificates, engineer caps, and spittoons were sold. Children throughout town pitched in. When the big day came and Caboose No. 520 arrived in 1987, it took its place of honor behind locomotive 3759. How it did, well—that's another story! Suffice it to say here, it was, "Kingman Pulling Together."

Two

KINGMAN SCENES
THROUGH THE YEARS

As with any community, Kingman continues to evolve. Fires, particularly in the early years, brought drastic changes and significant rebuilding. Economic growth and recession impacted the developing landscape of business as enterprises opened and closed. Population growth brought more homes and urban sprawl that impacted the older core of the town. In this chapter, images reflect Kingman's changing past and its enduring history.

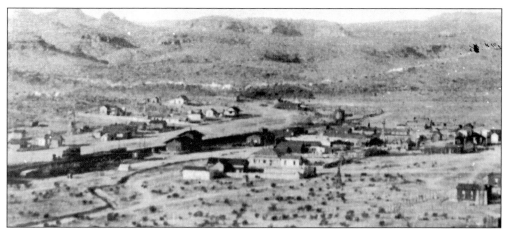

The railroad runs through the center of town in this c. 1888 scene, with the multilevel A&P Railroad depot seen slightly left of center. The long structures to the left of the depot along the tracks are coal chutes.

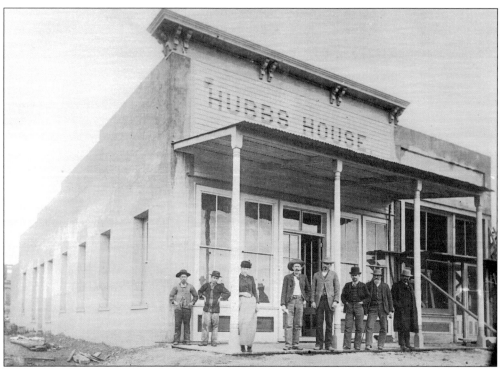

Seen here in late 1886, the first Hubbs House was essentially a restaurant and was one of the earlier buildings in Kingman. Located on the north side of Front Street (Andy Devine Avenue) between Third and Fourth Streets, it was destroyed by a large town fire in June 1888. Joanna Hubbs (third from left) and Harvey Hubbs (fifth from left) are the only people identified in this photograph. The two Chinese men on the far left are believed to be the restaurant's cooks.

24

After a devastating town fire in June 1888, the Hubbs House was rebuilt and reopened in February 1889. In January 1890, a second story for lodging was added. While it was still a successful venture, Harvey Hubbs sold the facility to Thomas Baker in January 1891 for $4,000. This building was destroyed by another town fire in May 1898.

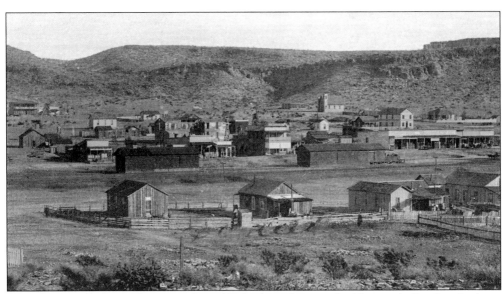

This photograph shows Kingman about 1890, when the town had been rebuilt after the large fire in June 1888. Among the new structures are the unfinished, unpainted two-story courthouse (upper left), St. Johns Methodist Church (upper right center), and the new Hubbs House with its second story (center of photograph).

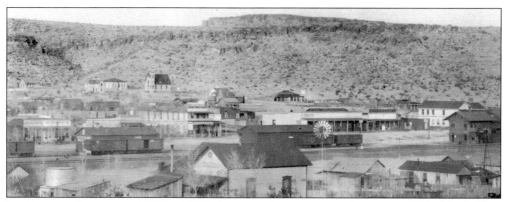

In this image from around 1892 to 1894, the new, white two-story Commercial Hotel (right) has been in place since 1891, and there are more private homes. Along Front Street on the north side of the railroad tracks is the Luthy Block of stores (white building directly behind the windmill). To the left of the Luthy Block is the two-story Hubbs House. Along the track are railcars, warehouses, and the A&P depot (on the right). That depot would burn down in April 1900 and be replaced by a new AT&SF depot.

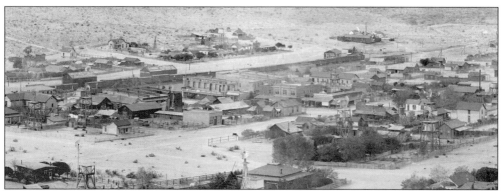

By the early 20th century, Kingman's commercial core had recovered from the large town fire of 1898. The new AT&SF depot (far left) opened in December 1900. Another new structure is the Hotel Beale (center), built by Mulligan and Hubbs. It was also completed and opened in 1900. A cow grazes on Beale Street directly across from the Mohave County Miner building (lower center).

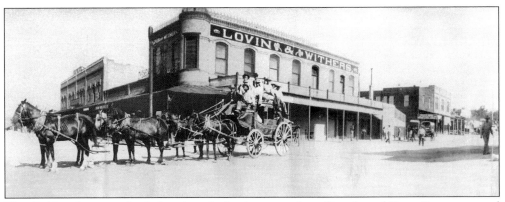

The Goldroad stage is loaded and ready for departure from Fourth and Front Streets around 1902. At this time, the offices of the stage company were located on the first floor of Lovin and Withers.

In this *c.* 1904 image, John Kolar, Mohave County supervisor from 1900 to 1908, sits in a cart at the intersection of Third and Spring Streets, near the Mohave County courthouse. Kolar was a blacksmith by trade.

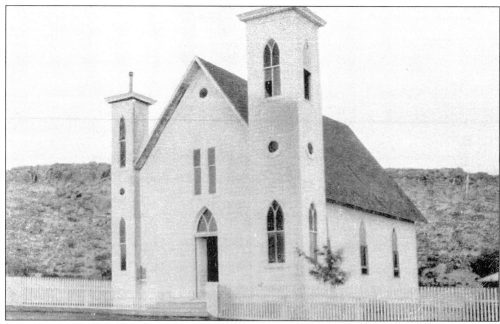

Completed in 1889 and dedicated in 1890, St. Johns Methodist Church was the first church built in Kingman. It was located at Fifth and Spring Streets. In 1918, the wooden church was moved and replaced by a stone church at the same location. The original wooden church was moved to the east end of Spring Street and converted into the Church Apartments. This photograph was taken in 1913 by H. H. Watkins to be sold as a postcard in his drugstore.

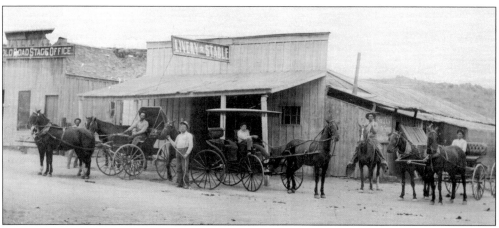

This is a c. 1901–1902 photograph of the Gold Road Stage Office and City Livery Stables. The two buildings are located on the southeast corner of Fourth and Oak Streets. During this two-year period, proprietorship changed hands three times: from Russell and Lane to J. D. Lane and West to Ayres and Boner.

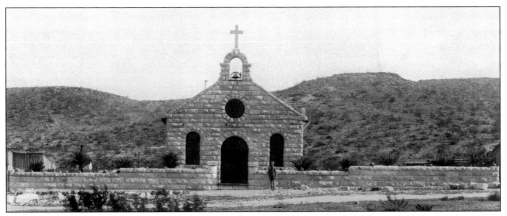

Pictured here around 1910, St. Mary's Catholic Church was the first Catholic house of worship in Kingman. It was constructed out of locally quarried tufa stone in 1906 and opened for services in 1907. St. Mary's is just east of the northeast corner of Third and Springs Streets.

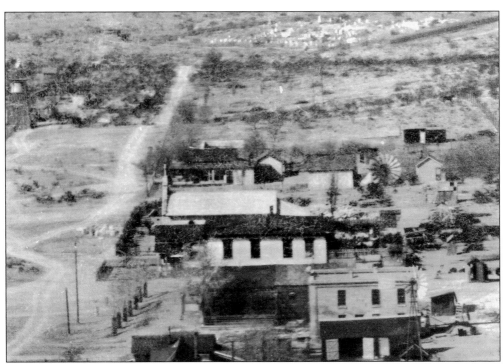

Looking west down Spring Street in 1909, from the county jail and courthouse to the Pioneer Cemetery, an interesting feature has caused people to divert to the left around the front of St. Mary's Catholic Church. The construction area with large stone blocks is what will become the Greystone Inn.

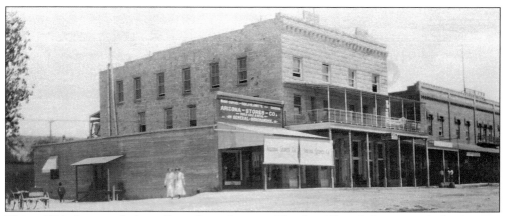

This *c.* 1910 photograph shows Front Street between Third and Fourth Streets, with the Arizona Stores Company, Brunswick Hotel, Lovin Building, and the Beale Hotel.

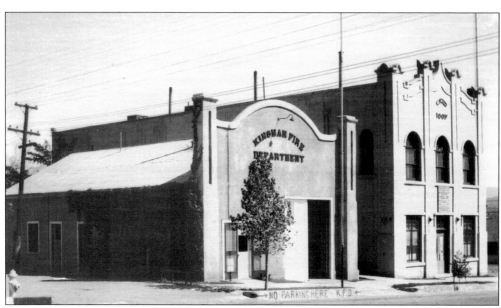

Located on the east side of Fifth Street, just north of the Beale Street intersection, the Kingman Fire Department and the Independent Order of Odd Fellows (IOOF) building still command interest. The IOOF building was completed in 1911, and the Kingman Fire Department occupied its home in 1922. This photograph is from around 1927.

Always ready for a parade, Kingman turns out in large numbers for this 1930 celebration along Front Street. Many folks backed in their cars on the south side of the street to create their own viewing stands with comfortable seats.

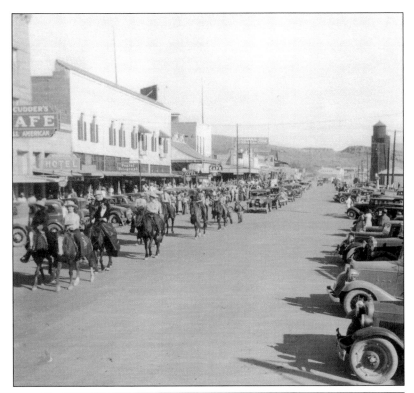

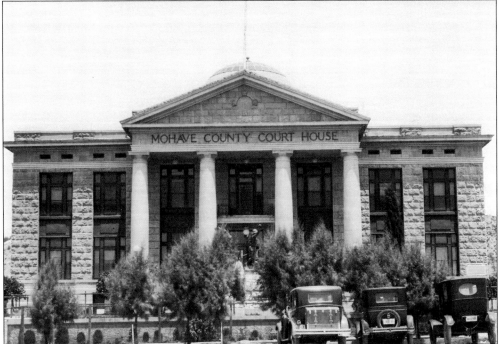

Mohave County's new tufa stone courthouse opened in 1915, on Spring Street at the end of Fourth Street. It is shown here in the late 1920s or early 1930s, with the World War I Memorial in place and maturing landscaping.

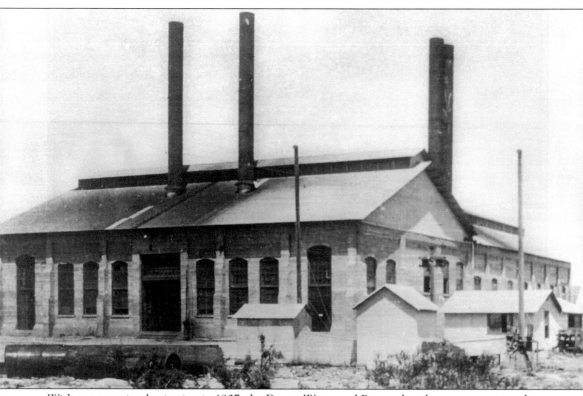

With construction beginning in 1907, the Desert Water and Power plant became operational in July 1909. Its main purpose was to provide electrical service to the mines of the Goldroad area in the Black Mountains. The first resident of Kingman to benefit from this new power source was J. E. Perry. By October 1909, most businesses and numerous homes were connected. The plant would eventually expand its service to include all of Kingman and additional mining areas in the Black and Cerbat Mountains. It was purchased in 1927 by the W. B. Foshay Company of Minneapolis, which set up a management company called the Public Utilities Consolidated Corporation of Arizona. Citizens Utilities Company became the owner in 1935. The plant would be relegated to a backup status after electricity came on line from Hoover Dam in 1938. It would cease operation completely in 1940. By the 1970s, the building was nothing more than an unused, empty hulk. In 1984, a group called the Powerhouse Gang incorporated as a nonprofit entity and did much of the early assessment and survey work to save the structure. In 1990, T. R. Orr took up the cause and through much hard work saw the project completed. This photograph is from around 1925.

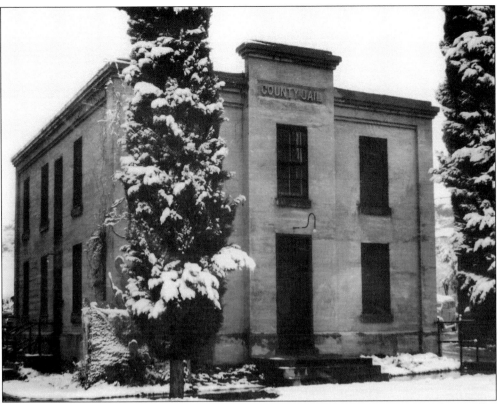

Seen here after a rare snowfall, the Mohave County Jail was constructed in 1909 and opened in 1910. It was still being used when this photograph was taken around 1940. The building's dark, unlighted basement was a storehouse for county records for many years.

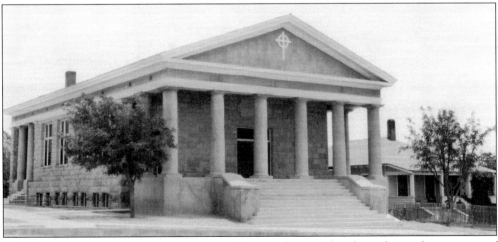

In 1918, construction started on the new St. Johns Methodist Church on the southeast corner of Fifth and Spring Streets. Fashioned of stone, the building is still in use today as Mohave County offices. A new St. Johns Methodist Church was erected at Kino and Western Streets in 1992.

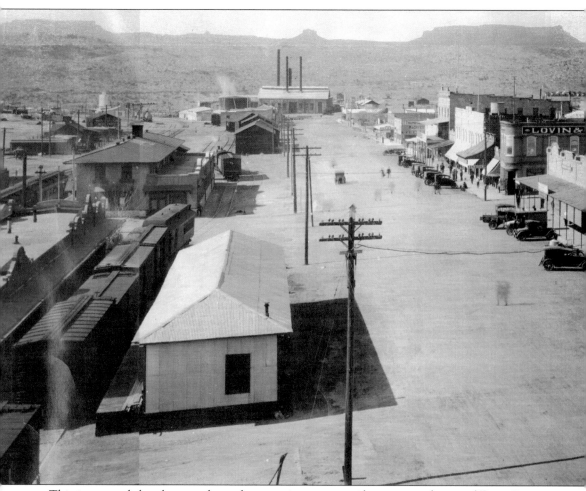

This image and the photograph on the opposite page provide a westward view of Front Street around 1920 or 1921. From the foreground to the rear on the left side are the Atchison, Topeka and Santa Fe Railway annex and depot; the Kingman Harvey House; warehouses for local merchants Arizona Stores Grain and Feed, Tarr, McComb and Ware, Lovin and Withers; and the Public Utilities Consolidated Corporation of Arizona's powerhouse. From the foreground to the rear on the right are the western portion of the Luthy Block, with Kingman Drugs on the corner; Lovin and Withers commercial building; the Gate Way Cafe (with a sweeping porch roof); Hotel Beale; Lovin Building (small building between the two hotels); Brunswick Hotel; Thompson's Garage; and Arizona Stores Company.

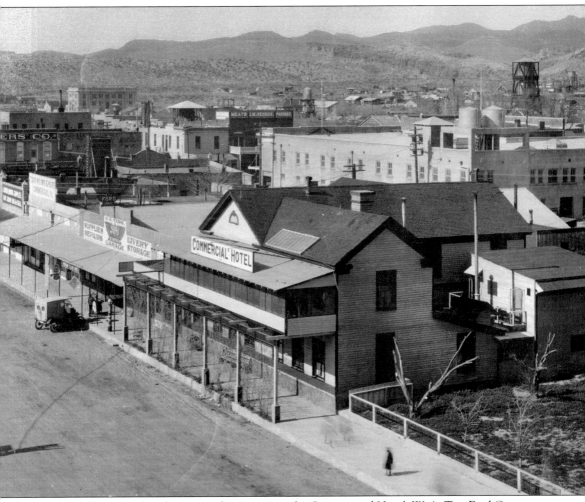

From the foreground to the rear in this image are the Commercial Hotel; W. A. Tarr Ford Garage; Tarr, McComb and Ware commercial company; S. T. Elliott; Furnishings and Men's Wear (part of the Luthy Block). To the right of the back half of Lovin and Withers are George Bonelli's store and I. M. George Meats and Produce. The large building on the upper right is Central Commercial Company. In the far back left of the photograph is Kingman High School.

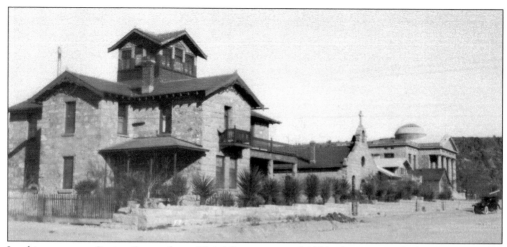

Looking east on Spring Street from Third Street around 1930, the view includes three notable structures all constructed of native tufa stone—the Greystone Inn (left), St. Mary's Catholic Church (center), and the Mohave County courthouse. A newer St. Mary's Catholic Church has since replaced the Greystone Inn, but historic St. Mary's and the courthouse still stand.

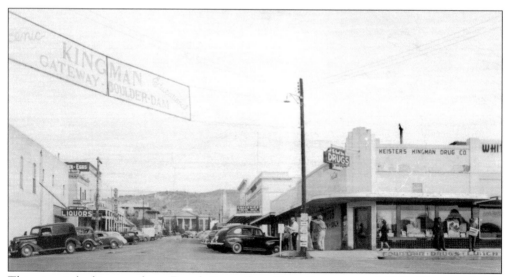

This view is looking north on Fourth Street from Front Street around 1940. The courthouse can be seen at the end of Fourth Street. Kingman Drug is on the right and behind it is Central Commercial.

Three

THE BUSINESS OF GROWTH

Businesses in Kingman have always been as varied and interesting as any modern marketplace. The entrepreneurs of the past worked hard to make their lives better and gave greatly to the community to help it grow and prosper—a character that Kingman still exhibits today. Many long-term successes are recorded in the photographs presented here. It is hoped that what follows provides a small and sometimes intimate glimpse of who and what was here and a sense of what has changed.

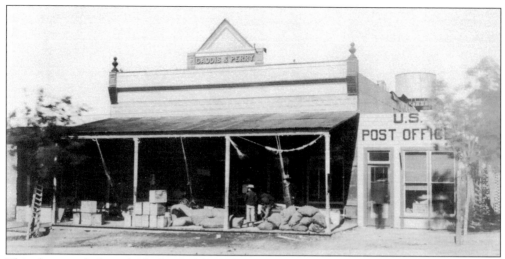

This photograph shows both the Gaddis and Perry mining supplies and mercantile store and the Kingman post office along Front Street (Andy Devine Avenue) around 1890.

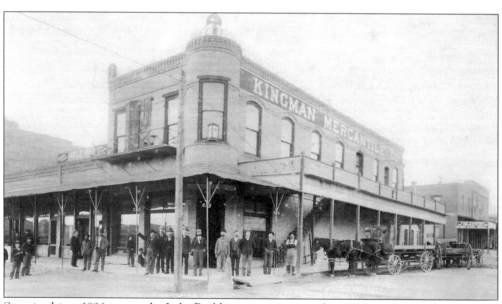

Seen in this c. 1896 image, the Lake Building was constructed in 1895 on the northwest corner of Fourth and Front Streets. Over the years, it housed a meeting hall, several mercantile stores, the post office, private professional offices, a stage line depot, and other miscellaneous businesses. In 1901, Lovin and Withers replaced the Kingman Mercantile name.

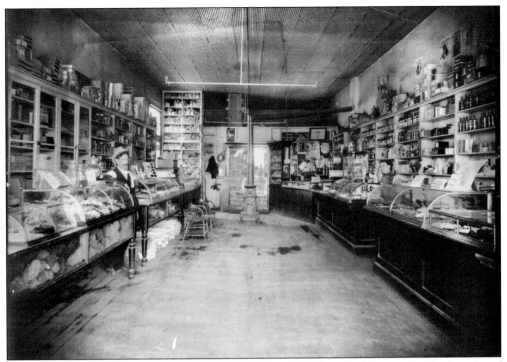

Howard H. Watkins (left) and his wife, Jessie Tolman Watkins (right), pose in the interior of Watkins Drug Store on the northeast corner of Fourth and Front Streets around 1897.

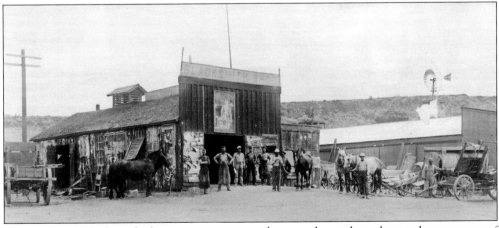

Jack Maddux's blacksmith shop was a prominent business located on the northeast corner of Fourth and Beale Streets. No one is identified in this c. 1900 photograph, but it is believed that the fellow in front of the open door with his hands on his hips is Maddux.

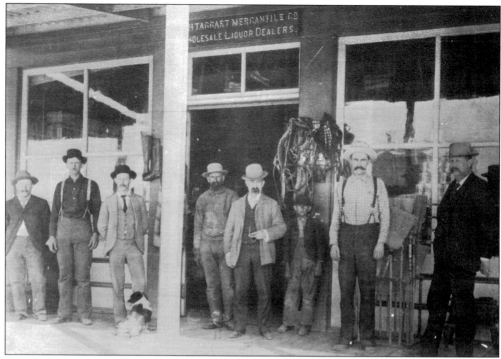

A group has gathered in front of W. H. Taggart's mercantile on Front Street around 1900. They are, from left to right, unidentified, Asa Harris, two unidentified, W. H. Taggart, Clarence Wilson, Henry Lovin, and Walter Vernuhr.

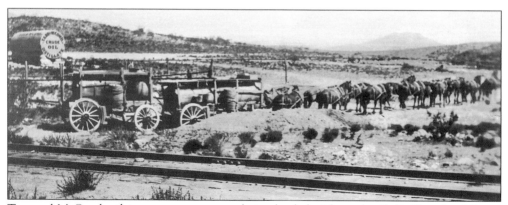

Tarr and McComb oil transport wagons are being loaded with crude oil distillate for delivery to a mining community outside of Kingman in this c. 1900 photograph. Almost all freight and supplies to the mines in the area came through the Kingman rail yards after 1885.

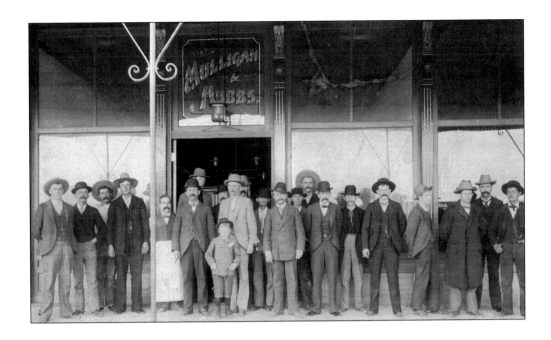

The gentlemen assembled for this *c.* 1900 photograph (above) look more like a gathering to promote the opening of a new business than simply customers posing for a picture in front of the Mulligan and Hubbs saloon. The establishment was located on Front Street between Third and Fourth Streets. The only people identified are Harvey Hubbs (left center, behind the young boy) and Henry Lovin (back right center, with a large brimmed hat pushed back on his head). In an interior shot of the saloon (below) taken around 1907, the "& Hubbs" has been removed from the sign above the door.

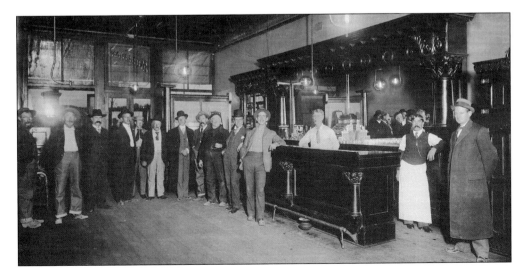

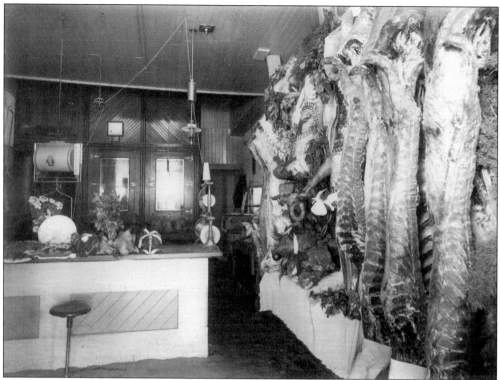

The I. M. George meat and produce market was for many years the premier meat market in Kingman. These photographs date from around 1904. In the photograph below, the George children pose with the diverse products offered for sale.

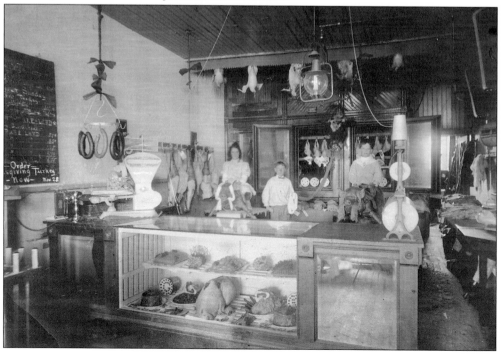

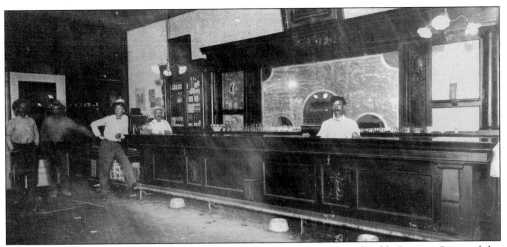

The Arcade Saloon was located on Front Street between Fourth and Fifth Streets. Some of the customers in this c. 1905 photograph seem to want to blend into the background.

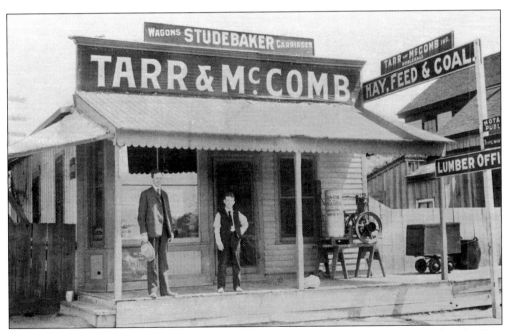

While this photograph allegedly dates to sometime between 1902 and 1904, just after the Tarr and McComb store opened, historical documents indicate that the store opened in 1908. Allen E. Ware is the tall man on the left.

This small gathering of local businessmen on Front Street around 1910 includes, from left to right, Edward Thompson, Allen E. Ware, two unidentified, Charles Van Marter, Tom Devine, two unidentified, and J. Edward Perry.

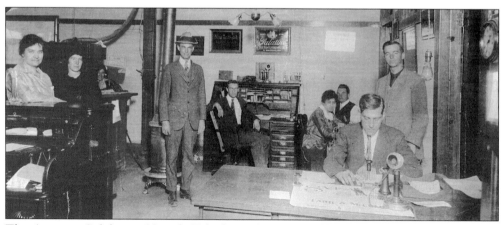

The Arizona, California, Nevada Telephone Company office is shown here around 1911. Inside the office that day are, from left to right, stenographer Hulda Ericson, two unidentified workers, R. L. Anderson, J. Max Anderson, operator Virgina Noli, a Mr. Park, Bill Deeter, and Otis Willoughby.

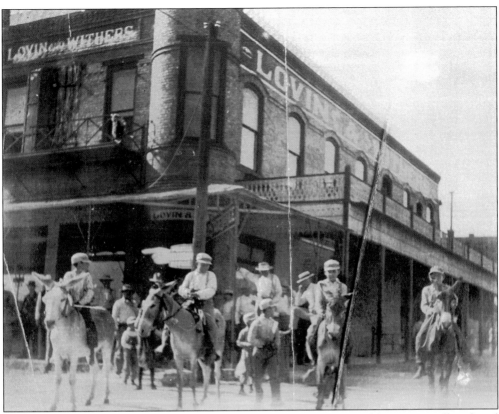

Around 1912, Lovin and Withers was the major tenant in the Lake Building, eventually referred to as the Lovin and Withers Building. The explanation for the boys on burros in front of the store is unidentified.

Located in the Lake Building, Lovin and Withers mercantile stocked a variety of goods for the public. No one in this 1912 photograph is identified. A woman in the center is probably a member of the local Hualapai tribe. Many Hualapis would trade or sell handmade crafts to local merchants for resale.

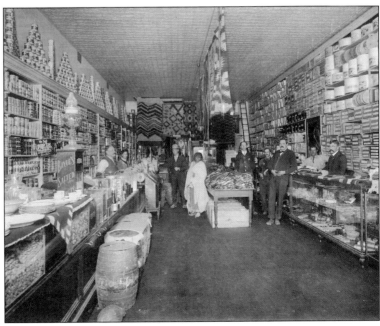

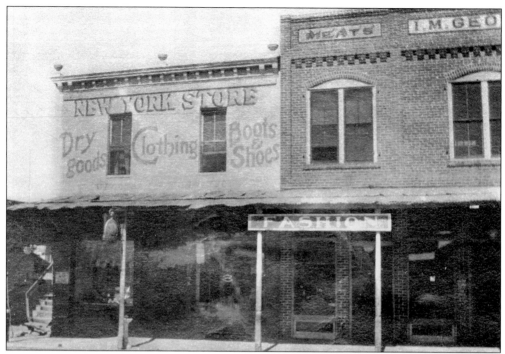

This *c.* 1911 photograph shows George Bonelli's New York Store, the Fashion saloon, and I. M. George's Meat Market on the west side of Fourth Street between Front and Beale Streets.

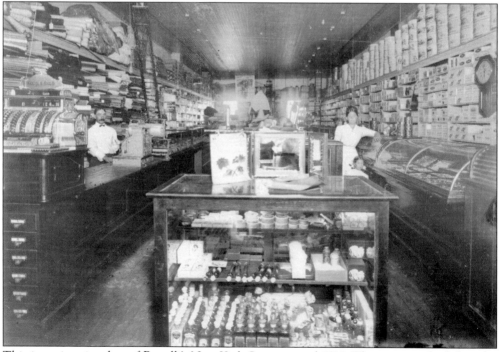

This is an interior shot of Bonelli's New York Store around 1911. The man on the left is the store clerk, and the woman and child on the right appear to be customers. None is identified by name.

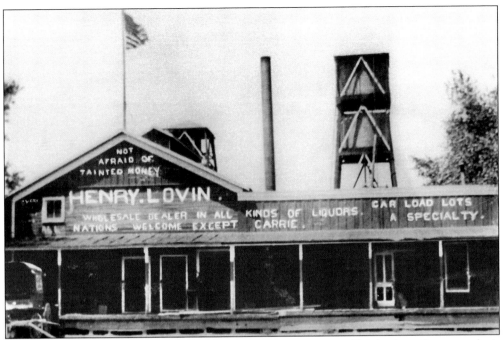

Seen here around 1912, Henry Lovin's liquor store was just one of his business interests. As is evident, Lovin missed neither the truth nor the humor possible in advertising. This building was located along the north side of Beale Street between Third and Fourth Streets.

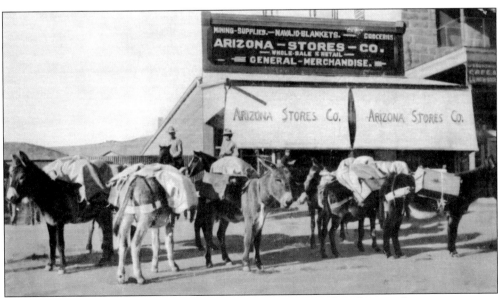

Burros played an extremely important role in the transportation of goods to rural mining operations well into the 20th century. This burro train is getting ready to depart the Arizona Stores Company on Front Street around 1913.

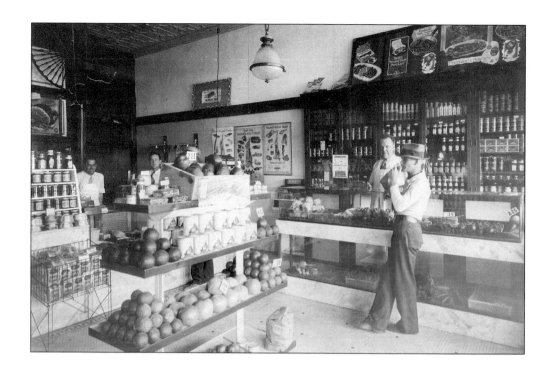

By 1915 or 1916, I. M. George's Meats and Produce market had taken on a much more modern atmosphere when compared to the 1904 photographs on page 42.

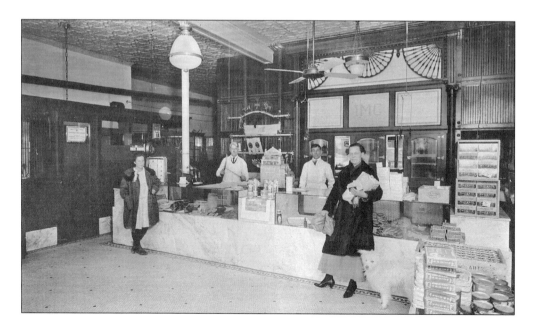

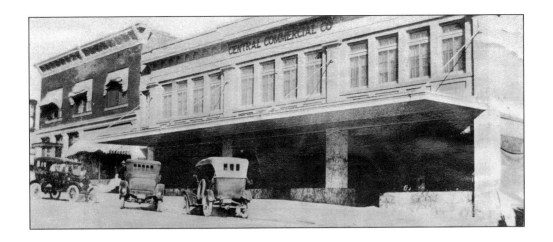

In 1918, a new, modern department store opened in Kingman that would be the premier shopping experience in town for 50 years. Central Commercial was a multilevel store that covered more then half a square block at the southeast corner of Fourth and Beale Streets. The brick building on the left was not initially part of Central Commercial but housed the Citizen's Bank and the post office on the ground floor and professional offices on the top floor. The photograph above is of the side of Central Commercial facing Fourth Street. Below are the stores' loading and shipping docks.

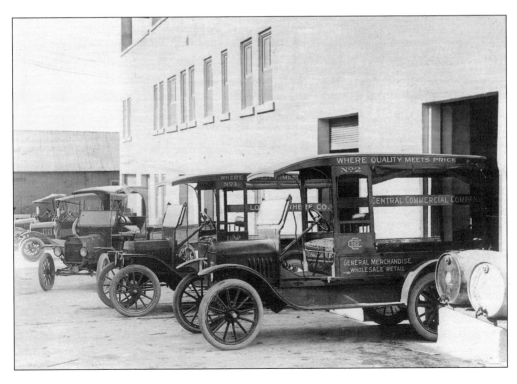

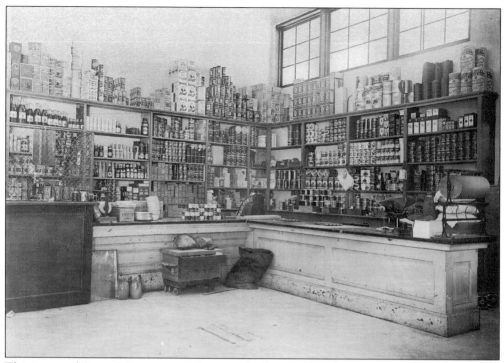

This is part of Central Commercial's large stock of grocery goods.

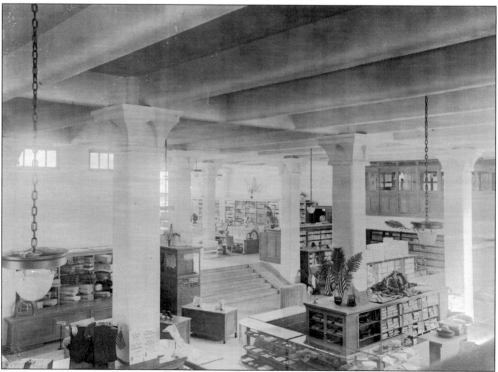

This photograph of Central Commercial shows a portion of the grand room with clothing, bolts of cloth, shoes, and ladies accessories.

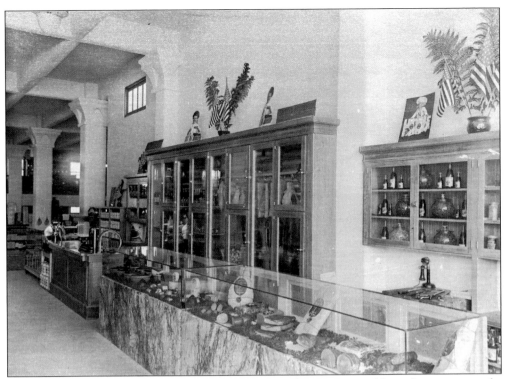

The liquor department and deli at Central Commercial were comparable to those in towns far larger than Kingman.

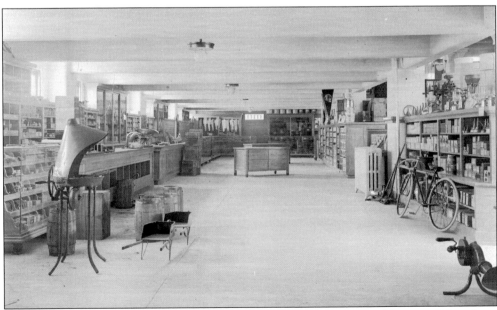

This is a view of the hardware section of Central Commercial. Basically, if the store did not have it, it was generally not needed.

By the time this photograph was taken around 1930, freight was coming in by train and truck. Here, Arthur Black poses with Jerome Carrow's Ford delivery truck that just brought in the first load of truck freight from Phoenix over the highway route that would become U.S. 93.

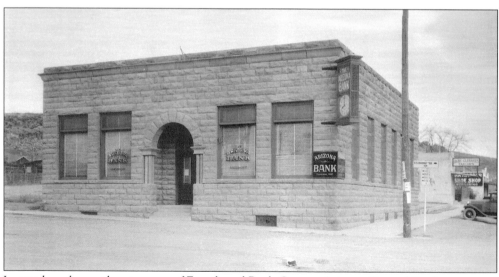

Located on the northeast corner of Fourth and Beale Streets, Arizona Central Bank was one of Kingman's best assets from 1912 until the end of the Depression. Pictured here around 1935, the bank's Kingman location did not survive into the 1940s.

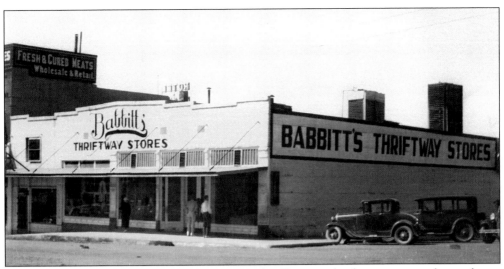

Babbitt's statewide chain of stores was represented in Kingman by this outpost on the southwest corner of Fourth and Beale Streets. Seen in this *c.* 1930 photograph, the store was destroyed by a fire in 1947 and was not rebuilt. Babbitt's would eventually take over the Central Commercial property across the street.

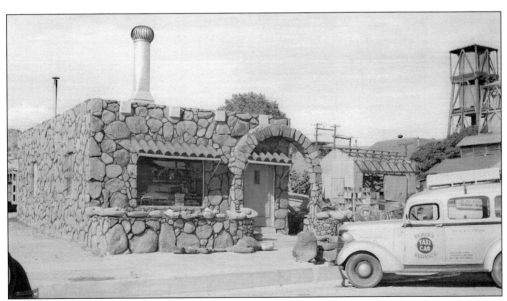

Arthur Black developed this unique stone building on the north side of Beale Street between Third and Fourth Streets into a bus and taxi terminal for Kingman. It is seen here around 1939.

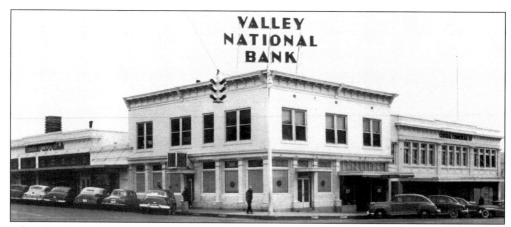

After the Citizen's Bank closed, Valley National Bank acquired this location at the southeast corner of Fourth and Beale Streets. Surrounded on both sides by wings of the Central Commercial building, the bank would eventually move to a location on the northwest corner of Fifth and Beale Streets. This photograph dates from around 1951.

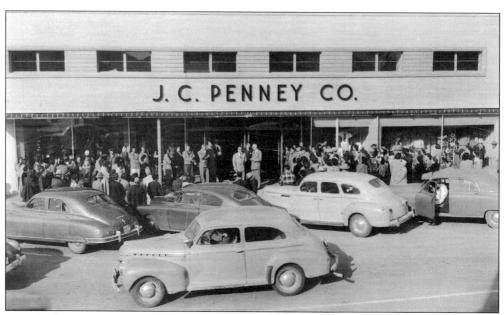

In 1951, the J. C. Penney Company held a grand opening. Located on the northwest corner of Fourth and Beale Streets, the store fronted Fourth Street. This modern department store was one of the first national chains to come to Kingman.

Four

THE COMING OF
THE AIR AGE

The air age began in Kingman with test flights at a small tract called Walapai Field, near the present-day Mountain View Cemetery. The first notes about it appear in the *Mohave County Miner* in December 1918. In February 1919, army aviators stopped at the field because of bad weather and lack of fuel.

Within 10 years, Kingman would have two airfields and celebrities like Charles Lindbergh and Amelia Earhart stopping by to promote both the airports and the new airlines serving them. Western Air Express put in the first airport at Berry Field, and Transcontinental Air Transport established Port Kingman. These early aviation giants would eventually combine and form Transcontinental and Western Air, Incorporated (TWA).

Both Airway and Airfield Avenues trace their names to the first airports in Kingman.

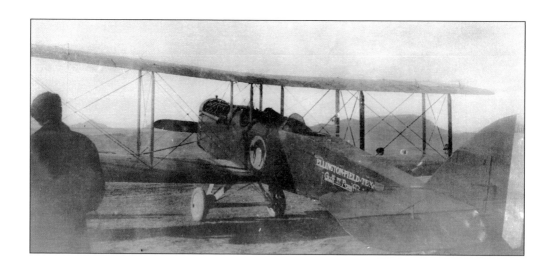

These are photographs of an early airplane visit to Kingman on February 22, 1919. This DeHavilland D-H4 (above) landed at Walapai Field (at the current site of Mountain View Cemetery) when it ran into bad weather and was low on gas. Part of a government-sponsored project for the future Transcontinental Air Transport (TAT) airline, the plane was scouting a route for landing fields. As Kingman had no suitable fuel for aircraft engines, cans of cleaning solvent were used to get the aircraft refueled and back on its way. The pilot was Jack Rice. Irma Lang (left, below) and her aunt Alice Smith Dundon get their first good book at an airplane.

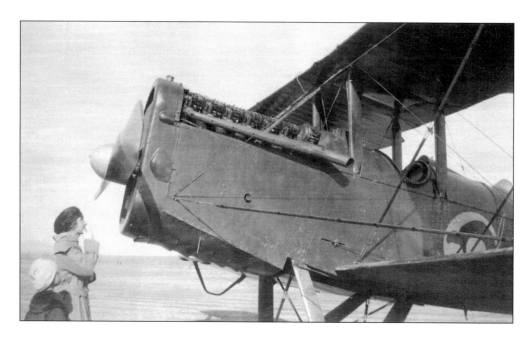

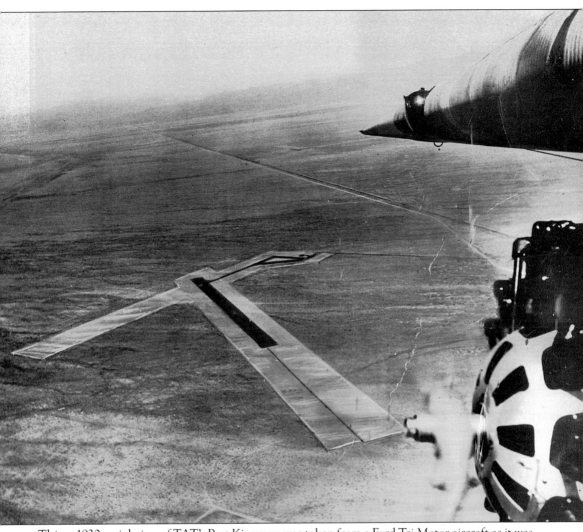

This *c.* 1930 aerial view of TAT's Port Kingman was taken from a Ford Tri-Motor aircraft as it was circling the field to line up for a landing. Above and to the right are the Santa Fe Railroad and U.S. 66. This photograph was taken looking northeast, and the closest part of the large runway actually reached across the current Interstate 40 into the county fairgrounds area. The terminal is in the upper area where the taxiways are located. The old terminal building is still there, along Bank Street. Much changed from its days as an airport facility, it has been a private residence and is currently a business location. A monument to Charles Lindbergh and Port Kingman is located at the current Kingman Airport. TAT would prosper and through a merger with Western Air Express would become Transcontinental and Western Air (TWA). In 1934, Western Air Express would sever its ties and eventually become Western Air Lines. Western Air Express had an earlier presence in Kingman at a small airfield named Berry Field near the railroad siding of Berry and on the east side of the tracks. Unfortunately, no pictures of the field or Western Air Express are available in the Mohave Museum's collections.

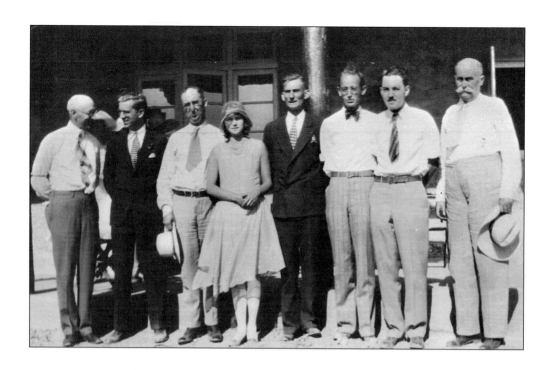

Port Kingman is dedicated on June 25, 1929 (above). The people shown are, from left to right, F. L. Hanna, assistant general freight and passenger agent from Phoenix; Patrick Murphy, TAT assistant general manager; P. G. Spilsbury, president of Arizona's Industrial Congress; Lois Gates, Miss Kingman; Willis Black, president of Mohave County Chamber of Commerce; Harry Brodt, TAT construction engineer; W. H. Grover, TAT meteorologist; Henry Lovin, chairman of the Mohave County Board of Supervisors. A small panorama (below) gives some idea of the excitement and large turnout that the event created in a small community like Kingman. Cars and people line the runway in this photograph, and other pictures show that hundreds of cars parked in front of the building.

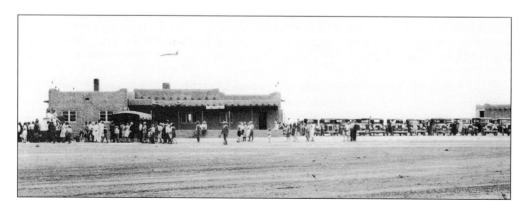

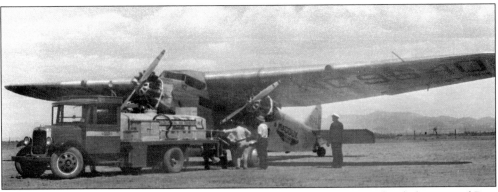

This Ford Tri-Motor belonging to Maddux Air was in attendance at the dedication of Port Kingman in 1929. This airline had a presence in Arizona as early as 1926 and would merge with TAT in 1929.

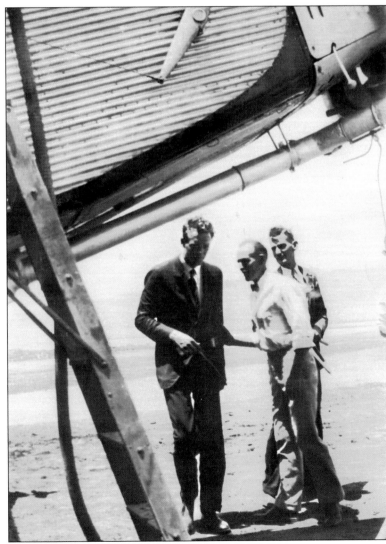

As part of the plane's inspection process on July 8, 1929, Charles Lindbergh (left) discusses the servicing procedure with airport manager R. M. Dunlap (center).

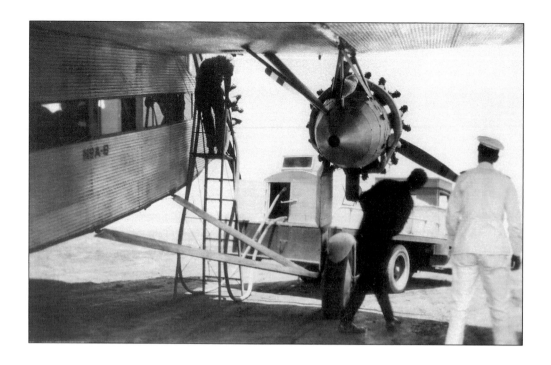

Charles Lindbergh inspects the Ford Tri-Motor aircraft *City of Los Angeles* (above) on July 8, 1929, at Port Kingman. Lindbergh continues his discussions with R. M. Dunlap, the airport manager (below). Promoting the new TAT system, Lindbergh made several trips to Kingman, along with his wife, Ann Morrow Lindbergh.

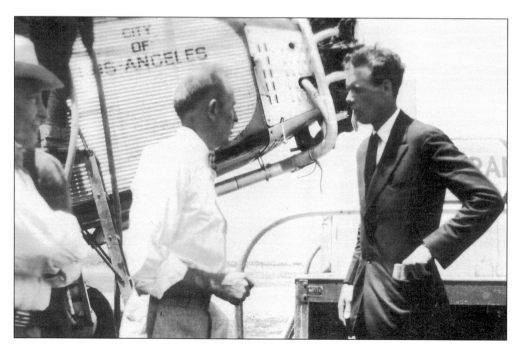

Charles Lindbergh reads one of the many telegrams acknowledging the airport dedication and congratulating him on his new venture with TAT.

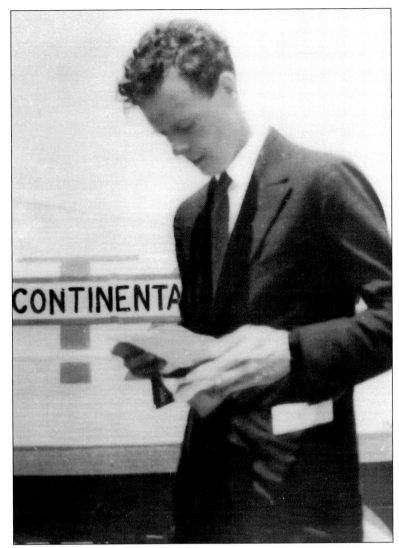

In this c. 1931 image, a billboard located along a relatively new U. S. Route 66 advertises the new Kingman Airport nearby. The air-rail service promised to expand locations people could get to via the highway.

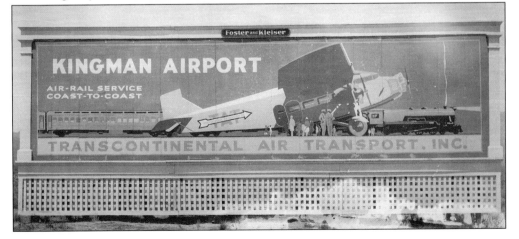

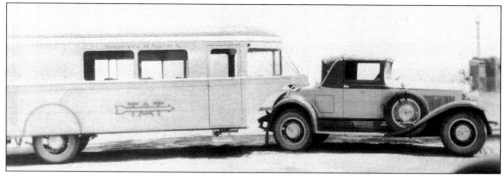

Shown here is Transcontinental Air Transport's surface transport delivering people to and from the terminal from downtown Kingman. All hotels, restaurants, personal services, and the train depot were located downtown at the time. This photograph was taken at the airport dedication ceremony on June 25, 1929. After passenger service started, this and other vehicles were used to deliver meals from downtown to the airport for those travelers passing through on a flight that just stopped to refuel.

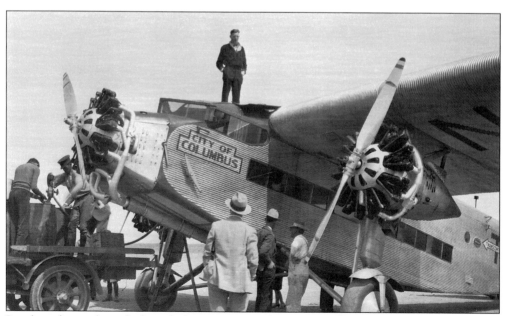

People gather and watch the refueling operation of TAT's Ford Tri-Motor passenger plane *City of Columbus* at Port Kingman around 1930.

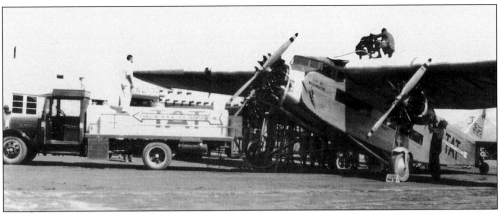

TAT's Ford Tri-Motor passenger plane *City of Washington* is being refueled at Port Kingman. The Ford Tri-Motor aircraft featured all-metal construction (rare for the time) using mostly aluminum. It was sometimes called the "Tin Goose." It was used in both civilian and military roles. Becoming the signature aircraft for TAT Airlines, it featured good passenger comfort and service.

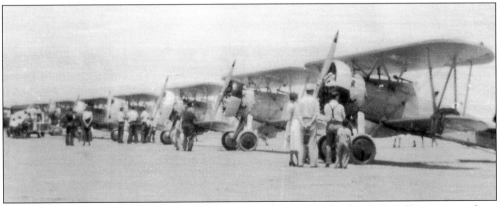

A squadron of U. S. Army Air Corps fighter aircraft went on display at Port Kingman on June 5, 1931. This was part of a cross-country public relations effort on behalf of the fledgling army air force.

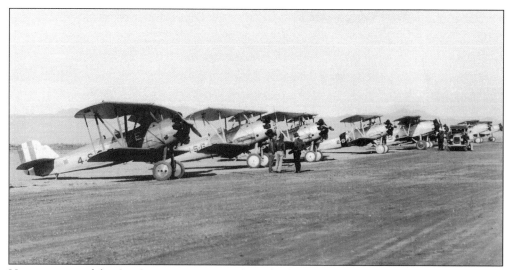

Here is a view of the Air Corps trainer aircraft on display at Port Kingman on June 5, 1931. This tour included the recruitment of men to become cadets to increase the number of pilots for the new Air Corps.

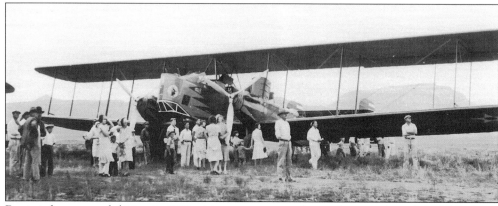

During the same exhibition in 1931, citizens were treated to a close-up view of the U.S. Army Air Corps' Curtis B-2 Bombers. This is just one of several in a flight of bombers brought in for the exhibition.

Five

AUTO TRAVEL AND TOURISM

Throughout its history, the Kingman area has been a crossroads. First it was a hub for the railroad and wagon-road exploration and survey teams in the 1850s, then came the actual wagon and toll roads of the 1860s and 1870s. In the 1880s, the railroad was built and greatly opened up the area. Next came the National Old Trails Road that would evolve into numerous state and federal highways.

Kingman's introduction to the automobile age coincided with the creation of the National Old Trails Highway system and flourished with the creation of the "Mother Road," U.S. Route 66. It has been a focal point and tourist service area ever since.

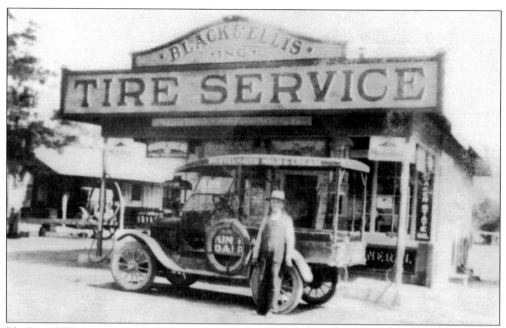

Black and Ellis was one of the first service stations to open in Kingman. It was located on the southwest corner of Fourth and South Front (Topeka) Streets. Ike Wheeler stands beside the Kingman Dairy Delivery Truck around 1910.

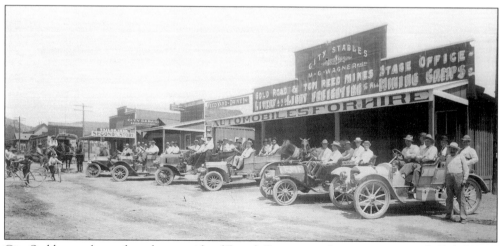

City Stables was located on the east side of Fourth Street near the intersection with Oak Street. The cars in front represent six of the total of eight automobiles in Kingman around 1910, when this photograph was taken. The closest car is a White-brand automobile specially equipped with 42-inch tires to allow it to navigate the high-centered roads of the time.

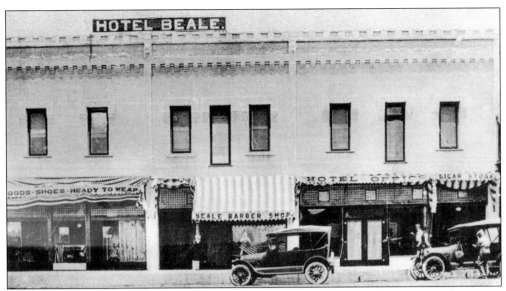

The Hotel Beale is shown here around 1915, when it was under Tom Devine's ownership.

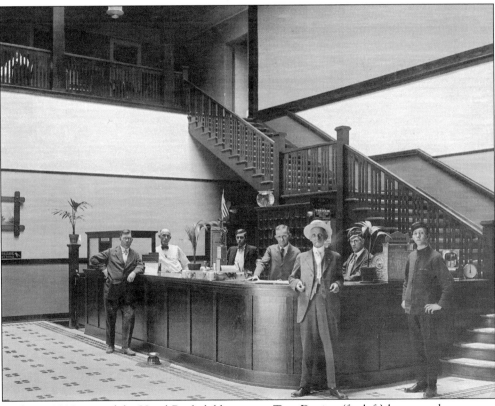

In this c. 1916 view of the Hotel Beale lobby, owner Tom Devine (far left) leans on the counter. Devine moved to Kingman from Flagstaff, Arizona, and purchased the hotel in 1906. He refitted it, increased the number of rooms, and made it into a modern lodging. Devine would become a leading businessman and serve as county treasurer. His son Andrew (Andy) would later become a well-known film and stage actor. The other men in the photograph are not identified.

By the 1920s, Black and Ellis had added used-automobile sales to its business offerings.

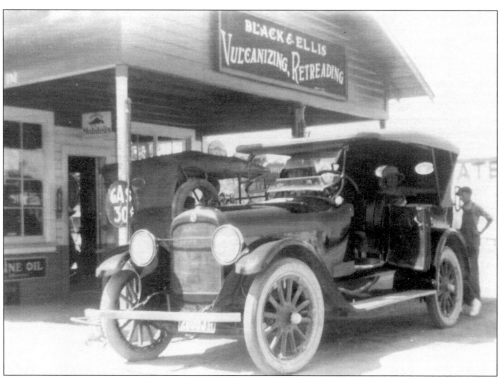

The remodeled Black and Ellis service station continued to evolve throughout the 1920s. Neither the ladies in the car nor the young man behind it are identified in this c. 1920s photograph.

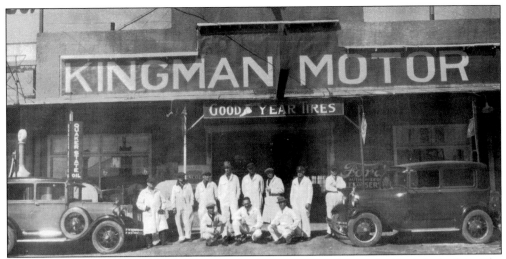

The Kingman Motor Company doubled as both a service station and a Ford dealership. The staff of the company poses with two of the cars offered for sale in the 1920s. Only one person is identified in this photograph: Arthur Black, standing third from left.

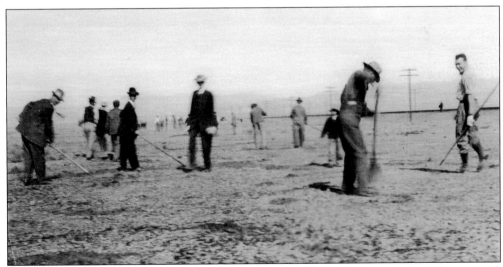

This *c.* 1925 photograph shows volunteers from Kingman smoothing gravel on the new U.S. Route 66 roadbed, preparing it to being paved into town.

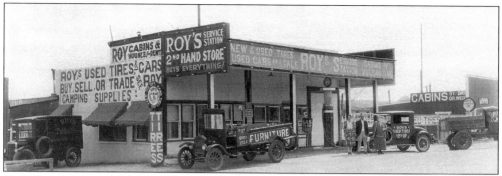

Roy's Service Station and Second Hand Store had something for everyone at its location on Beale Street between Second and Third Streets. Roy Walker offered auto service, tire service, used tires, used cars, secondhand merchandise, furniture, camping supplies, and houses and cabins for rent by the day or week. A sign in this *c.* 1930 photograph even indicates that he has "Gas Today." The people first and second from the left are Georgie "Tommie" Walker and her husband, Roy. The woman on the right is not identified.

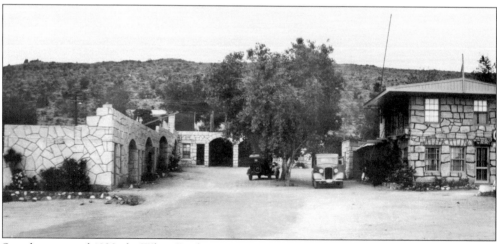

Seen here around 1930, the White Rock Motor Court on the northwest corner of Ninth and Front Streets was one of the early hostelries in town serving the traveling public along U.S. Route 66. It had 22 cabins with central cooling and heating, each with its own carport. The White Rock was a great example of the unique and interesting lodging facilities that sprang up to meet the needs of the motorcar travel explosion.

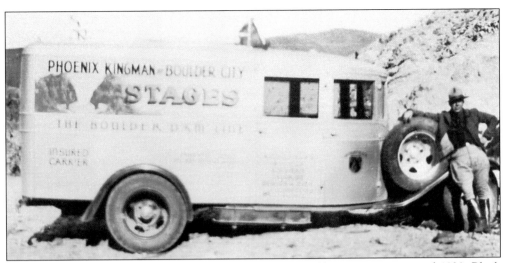

Arthur Black poses with his Phoenix, Kingman, and Boulder City stage around 1930. Black would become a local leader in the travel as well as general transportation trades for many years in northwestern Arizona.

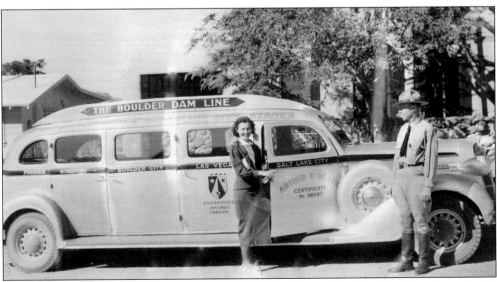

Arthur Black and his daughter Virginia pose with Black's new Boulder Dam Line limousine in this *c.* 1933 photograph.

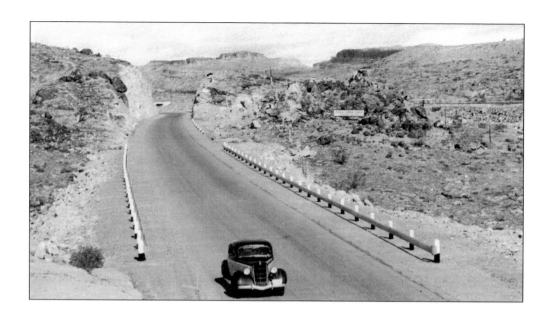

These two photographs were made to promote the new alignment of U.S. Route 66 when it was finished in the early 1940s. The photograph above shows what appears to be one of Arthur Black's cars for hire leaving Kingman through Railroad Pass. The photograph below shows the same vehicle coming into Kingman through Railroad Pass.

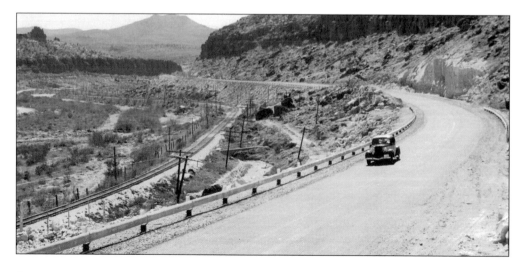

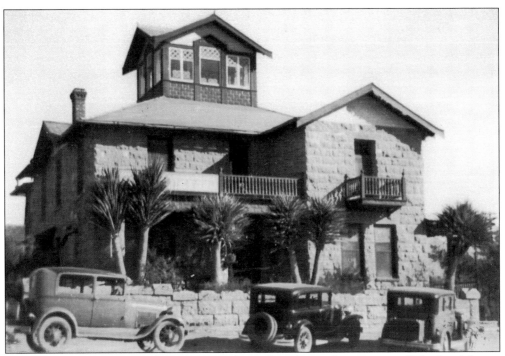

James Pendergast constructed this structure, located on the northeast corner of Third and Spring Streets, out of locally quarried tufa stone in 1909 and 1910. Between 1914 and 1918, it served as a hospital. In 1918, it was purchased by Delia T. English, who operated it as the Greystone Inn, which served the traveling public until 1940. This photograph is dated 1936.

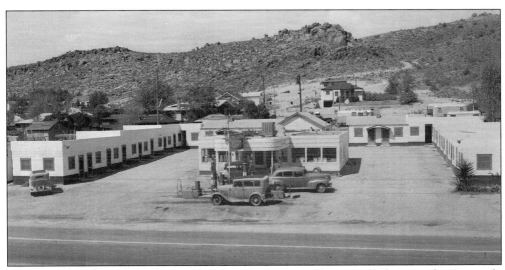

The 25-unit (eight with kitchenettes) Gypsy Gardens would eventually become the Coronado Motel. Seen here around 1948, it was one of many early motels to operate in Kingman along Route 66.

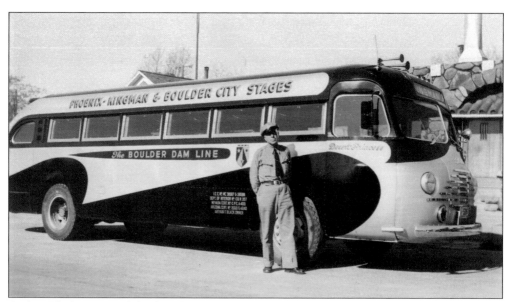

Arthur Black poses with his brand-new 1941 bus, the Desert Princess. This vehicle moved Black into the modern era of ground transportation for the traveling public.

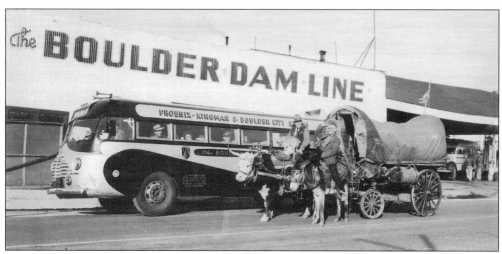

This was a "Then and Now" demonstration by Arthur Black to promote his new Desert Princess bus transport. It made a dramatic point: that only a short 30 years earlier, the wagon was still the basic transportation vehicle in use.

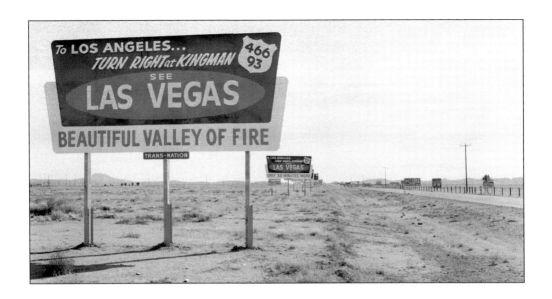

The c. 1940 photograph (above) shows numerous billboards just north of Kingman on U.S. Route 66 that promoted the attractions of Kingman and Las Vegas, Nevada. The new U.S. Route 93 crossed Hoover Dam, providing easy access to new resorts growing up in the Las Vegas area. During the same period, similar billboards (below) were located in downtown Kingman.

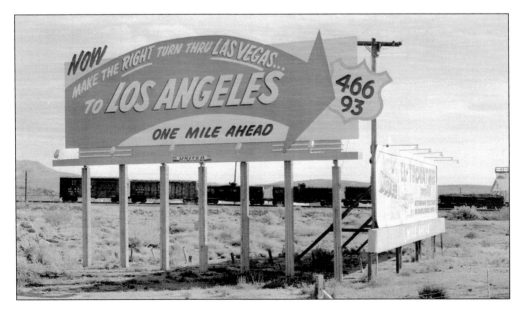

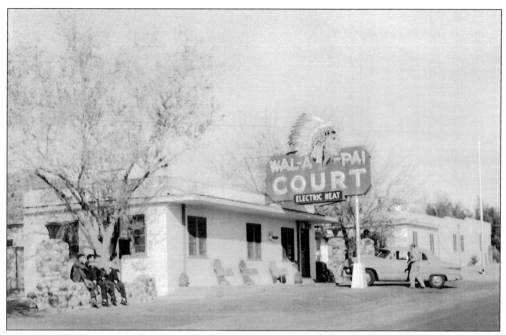

This c. 1950 photograph shows the WAL-A-PAI Court motel, located at 615 Front Street. Built in the late 1920s and remodeled on several occasions, it was one of Kingman's family-owned motor courts. When past its better days, it was known as the Star Motel, which was demolished in 2006.

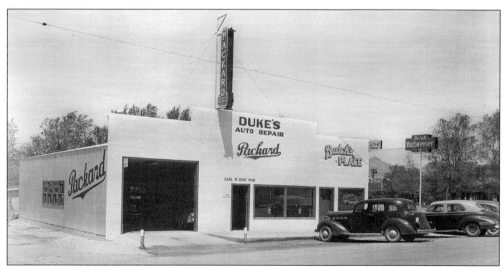

In 1946, Earl H. Duke's Auto Repair/Packard Service Center and Butch's Place tavern made an interesting business combination. The building was located on the west side of Second Street between Front and Beale Streets.

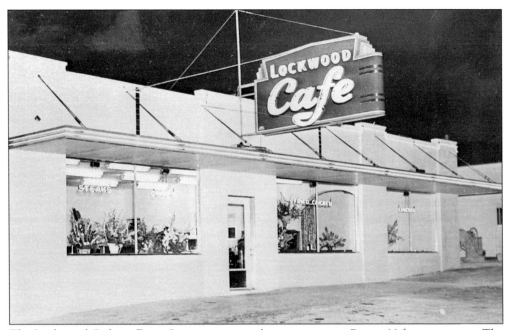

The Lockwood Cafe on Front Street was a popular restaurant on Route 66 for many years. The restaurant was a favorite of both travelers and locals when this c. 1950 photograph was taken. The building is currently a Catholic church.

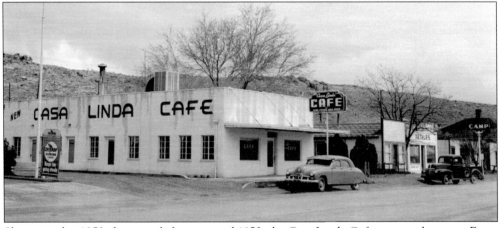

Shown in this 1950 photograph from around 1950, the Casa Linda Cafe was another great Front Street eatery on Route 66 through town.

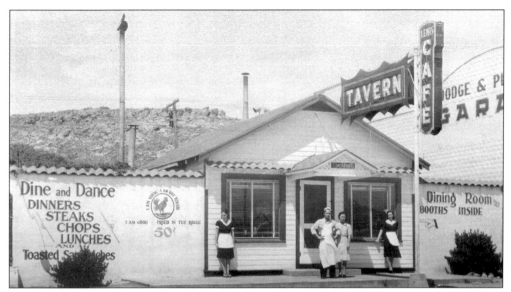

Lewis' Cafe and Tavern had the good luck to have Charlie Lum (center) as its cook. The other people in this 1940s photograph are not identified. Lewis' was located on Front Street between Sixth and Seventh Streets.

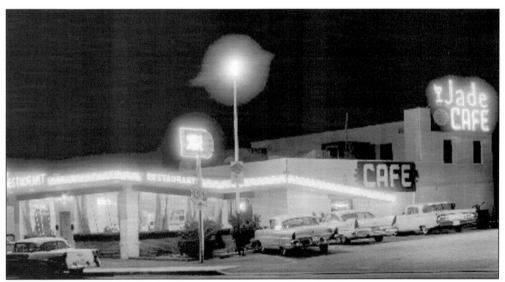

By the 1950s, Charlie Lum had his own restaurant, the Jade Cafe, located on the northwest corner of 10th and Front Streets. Lum featured both American and Chinese food in the cafe, a local favorite for many years. This photograph was taken in 1962.

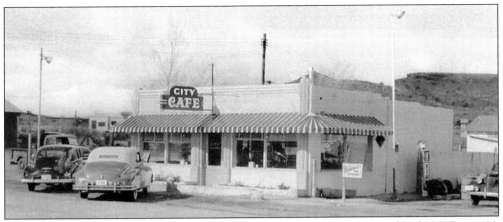

The City Cafe, shown around 1950, was on the corner of Stockton Hill Road and U.S. Route 66. Built by Roy Walker, it was a local and Route 66 favorite for more than 50 years. The cafe succumbed to old age and development and was demolished in 2009 to make way for a Walgreens.

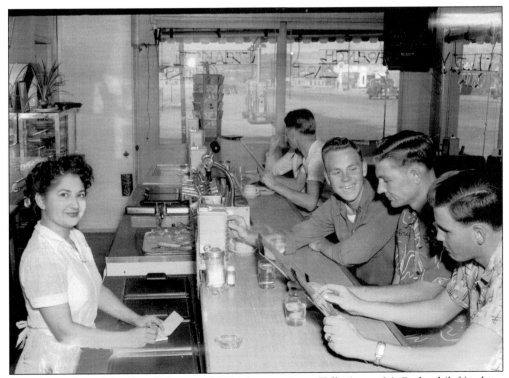

An interior shot of the City Cafe around 1954 shows waitress Tally Acuna McCasland (left) taking food orders from, left to right, Howard Tarr, L. D. Hagen, and Howard Britt.

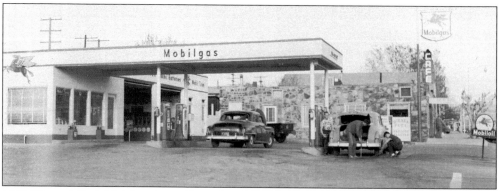

M. B. "Jimmy" Cox's Mobil station at Second and Front Streets was another fixture for the traveling public on Route 66 around 1955, when this photograph was made. Cox was an assistant chief of the Kingman Volunteer Fire Department and was one of eleven firemen killed in 1973 when a railroad propane tank exploded during attempts to put out a fire on it.

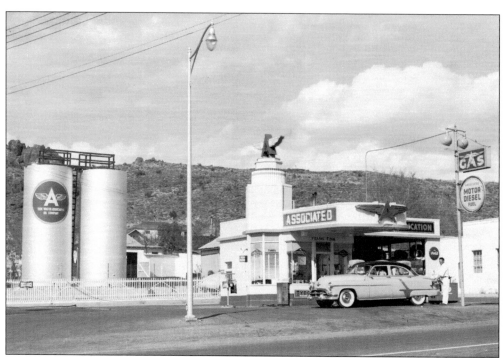

In this c. 1955 image, the Associated Gas Station, owned and operated by Frank Finn, sits on the northeast corner of Seventh and Front Streets next to the Lockwood Cafe.

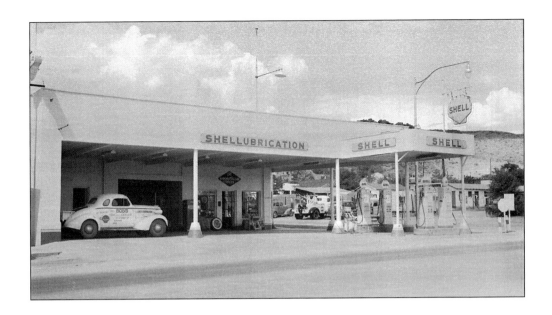

Robert M. Fitzsimmons was the proprietor of Bob's Shell Station (above and below), located on the northwest corner of Sixth and Front Streets. The people in the photograph below are not identified but may be the Fitzsimmonses. Both images are identified as being from the 1950s, but they may have been taken in the late 1940s.

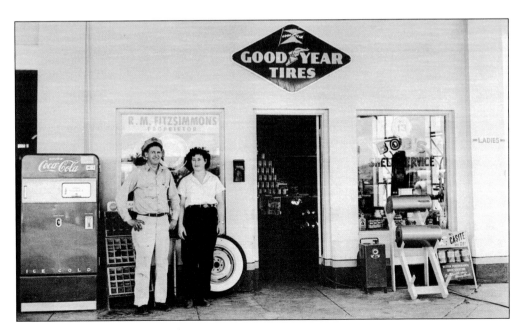

The Arcadia Lodge was located at the northeast corner of Ninth and Front Streets. The Arcadia was one of the larger early motor courts in the downtown Kingman area. It is still very active today, serving customers traveling on historic U. S. Route 66.

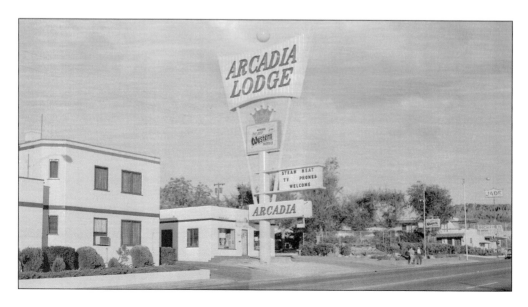

Six

THE WAR YEARS

Kingman weathered World War I without much change. Men and women served their country, and most came back home. The postwar years turned into a struggle as the American economy fell into the Great Depression. But because of its rural nature, Kingman was not impacted as badly as many other areas of the country. The largest effect came when the mines began to shut down in the 1930s.

The advent of World War II changed everything. Thousands of service men and women came to train at the new Kingman Army Air Field (KAAF). The town exploded with people and had a difficult time dealing with the surge. In the long run, the military base would benefit Kingman with new residents, new businesses, and, when the war was over, the airbase would become an industrial park that attracted companies and provided jobs.

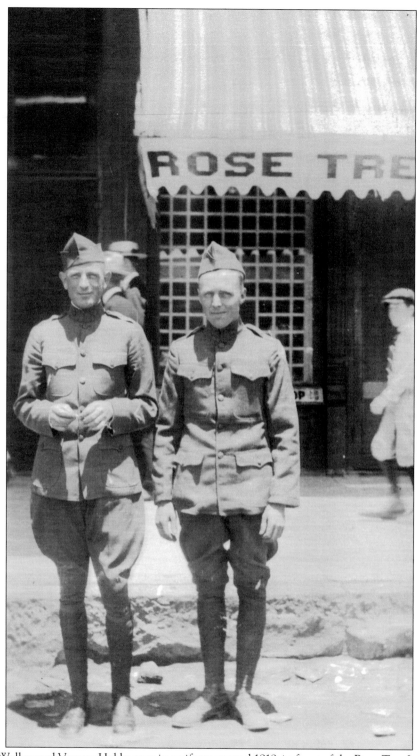

Cleve Walker and Vernon Hubbs pose in uniform around 1919, in front of the Rose Tree Ice Cream Parlor, which was between the Hotel Beale and Lovin and Withers on Front Street.

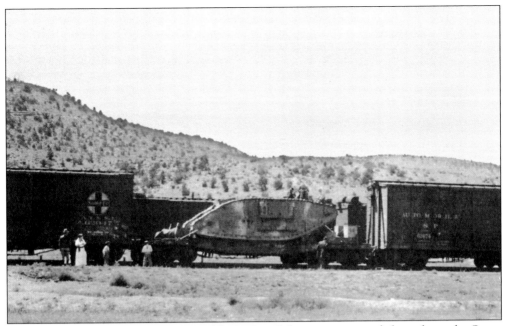

People have gathered to look at a World War I tank being transported through on the Santa Fe Railroad. Based on the clothing worn by the people in the picture, this is likely around 1918 to 1919.

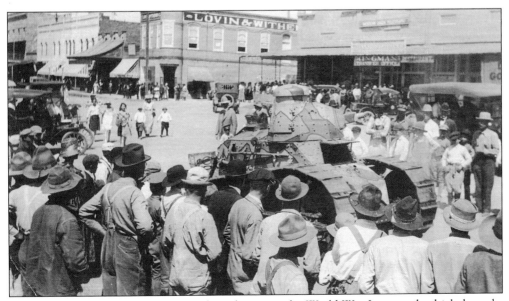

Around 1918, Kingman citizens eagerly gather around a World War I armored vehicle brought in to promote a Liberty Bond Drive.

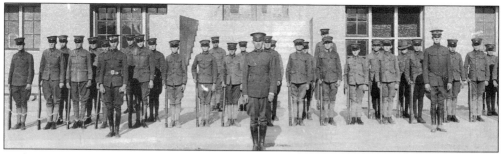

In direct response to the First World War, Kingman High School developed a Junior Reserve Officers' Training Corps program. This c. 1920 photograph shows cadets in drill order in front of the high school.

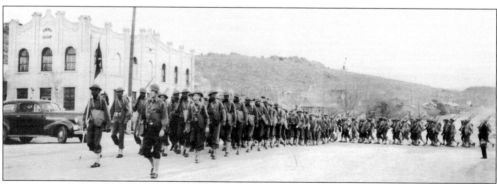

This may be an Arizona National Guard unit marching by the IOOF Building at the corner of Fifth and Beale Streets in an Army Day Parade in downtown Kingman around 1942. Based on the automobiles and military dress, it is probably near or just after the outbreak of World War II. Although the uniforms are an older style, the Jeep vehicles in the top photograph on page 87 (and from the same parade) did not exist prior to July 1941 and were not in active service until very late in 1941.

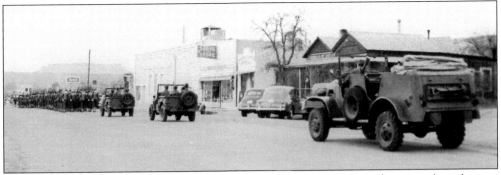

This photograph of the c. 1942 Army Day Parade shows Jeeps and a military truck at the rear of the parade.

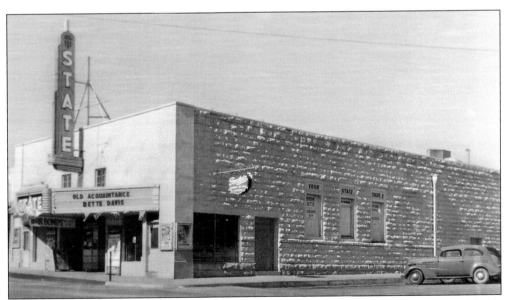

In this c. 1943 image, the State Theater located on the northeast corner of Fourth and Beale Streets has replaced the Arizona Central Bank. It is after the outbreak of the Second World War, as there are a number of signs on the front of the theater promoting the purchase of war bonds.

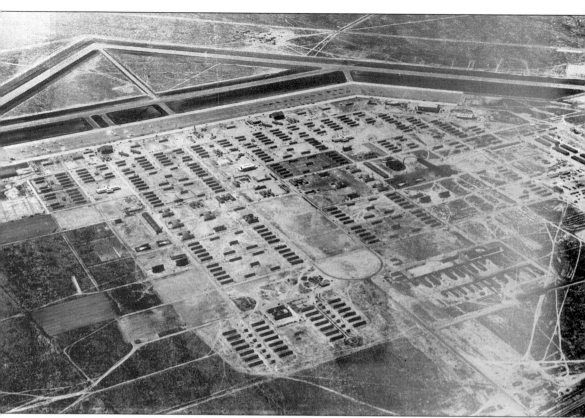

This aerial view of Kingman Army Air Field (KAAF) shows the extent of the area covered by the military establishment. Thousands of men were trained to become B-17 gunners at the Flexible Aerial Gunnery. Training started with classroom work, followed by using shotguns on trap ranges, then machine guns on ranges with moving targets. That was then followed by actual air-to-air firing exercises shooting at towed targets. The gunnery ranges used most of the northern part of Hualapai Valley and even today, .30 and .50 caliber bullets litter the desert in the area. There was a sub-base constructed near Yucca that used the southern deserts of Mohave County to augment the training area. That facility would become the Ford Proving Grounds in the 1950s.

Kingman Army Air Field's large American flag (right) strains the flagpole in the strong wind. Mascot Bugs Bunny proudly welcomes folks to the base (below). Warner Brothers Studios provided his image. In the official logo, Bugs is sitting in an aircraft firing a .50 caliber machine gun with a "determined" look on his face. This photograph dates from around 1943.

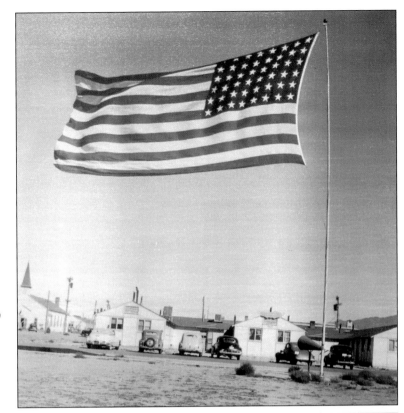

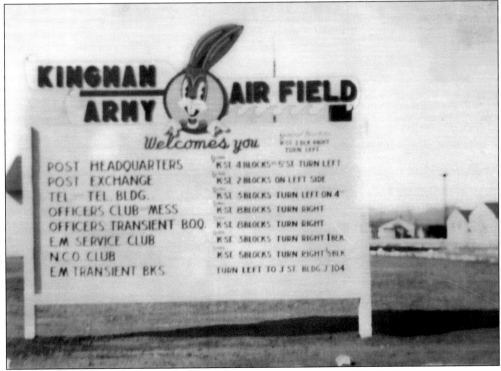

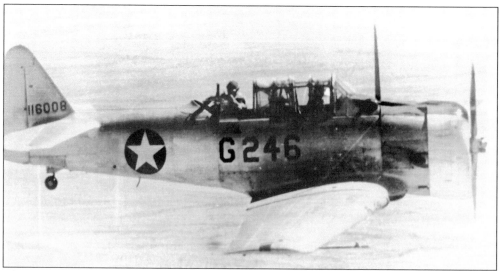

The first classes to advance to air-to-air firing practice used the North American "Advanced Trainer" AT-6 aircraft, as B-17s had not yet reached the base. In this c. 1942 photograph, a student can be seen at the .30 caliber machine gun.

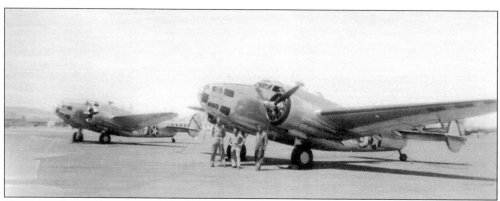

The next plane to arrive for training purposes was the Lockheed AT-18 Hudson. A ground crew assigned to this aircraft poses for the photograph around 1943. The Hudson aircraft originally flew light bomber and reconnaissance missions but were refitted to be used as gunnery trainers. The AT-18 was outfitted with a dorsal turret that contained a pair of .50 caliber machine guns for firing at airborne targets.

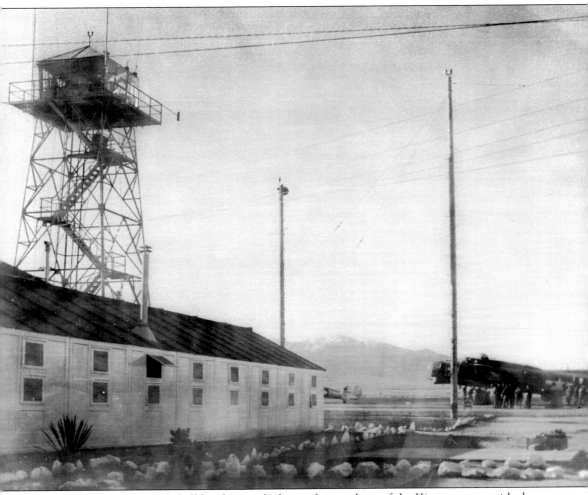

The KAAF tower provided all local control of aircraft in and out of the Kingman area with the assistance of a radar station placed on a tall hill near downtown. Although the radar is long gone, the hill is still known as Radar Hill. The B-17 in the background on the right is on the flight line with crews working on it. No longer a control tower, it is still in place today and is a historic landmark.

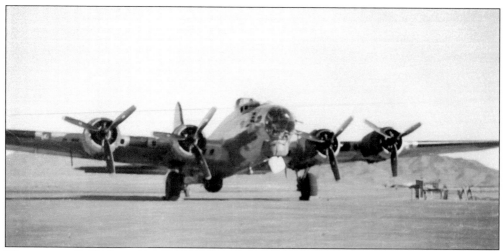

The majestic B-17 Flying Fortress was the workhorse bomber of World War II that would help turn the tide for the Allies. This photograph dates from about 1944.

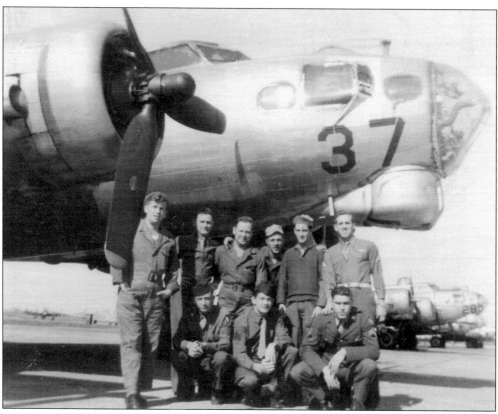

The crew here is proudly posing with its B-17 gunnery training aircraft around 1943. Hundreds of these planes were used at the base, and each had crews that were assigned to service and fly specific aircraft.

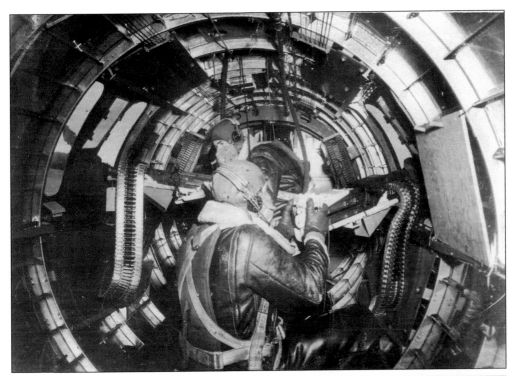

This *c.* 1943 photograph shows the waist gunner training positions in a B-17. These aircraft, while large, were not spacious or comfortable for the men flying in them. When at altitude, on the way to a target, the planes were very cold and noisy.

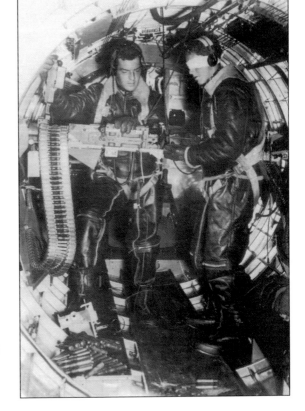

Training to become aerial gunners was extensive. In this *c.* 1943 image, trainee Robert Brockamp, from California, is blindfolded to simulate working with the machine gun in total darkness. Men needed to be able to load, clear, and fire from their stations in such conditions on night missions.

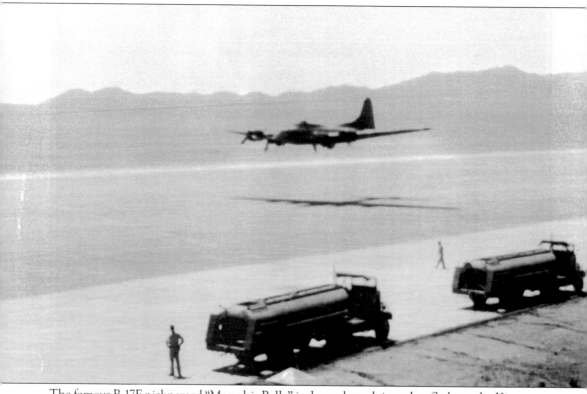

The famous B-17F nicknamed "Memphis Belle" is shown here doing a low fly-by at the Kingman Army Air Field in 1943. In the words of Lt. Col. Ralph H. Lessor, the Memphis Belle was doing "a triumphant tour of the United States to commemorate her spectacular combat career in Europe." One of the first bombers to complete 25 missions, it was sent home from England for a 31-city war bond tour in 1943. Cpt. Robert Morgan and his crew flew 29 missions during the war. All but four of them were in the Memphis Belle, named in honor of Captain Morgan's girlfriend in Memphis, Tennessee. The pinup nose art came from George Petty from *Esquire* magazine and was painted on both sides of the nose of the aircraft by Cpl. Tony Sparcer—in a blue swimsuit on the port (left) side and a red swimsuit on the starboard (right) side. Eventually, 25 bombs would be painted on the fuselage to reflect the number of missions. Included below the bomb images were eight swastikas to represent the eight German airplanes the crew claimed it had shot down. The Memphis Belle is currently undergoing extensive restoration and will be a permanent display at the National Museum of the U.S. Air Force near Dayton, Ohio.

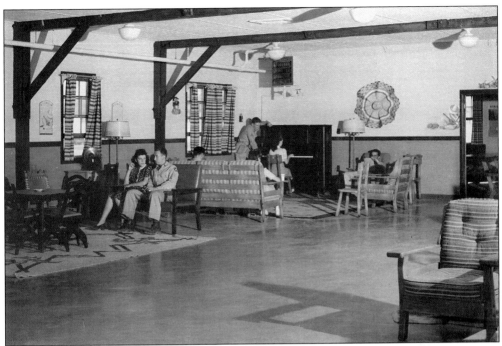

This is an interior shot of the Kingman Army Air Field Service Club, where enlisted men could spend time with each other in a social setting. Civilian employees and volunteers staffed such clubs. This c. 1943 photograph appears to be staged for the publicity purposes.

Between the years of 1943 and 1945, Cleo Daily Brown served as the service club director. Her job was to oversee the social activities and local volunteers who worked at the events.

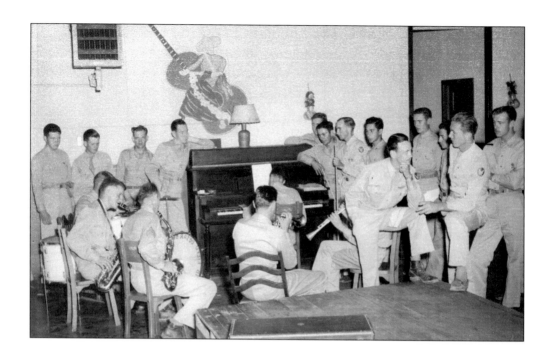

The jam session (above) and service club dance (below) provide a more accurate portrayal of the activities that surrounded the use of the club around 1943. The ladies in the photograph are local volunteers who would attend service club activities in support of the men stationed far from home. The ladies below are, from left to right, Katie Miller, Doris Cooper, June Roe, and Delia Walker. The servicemen are unidentified.

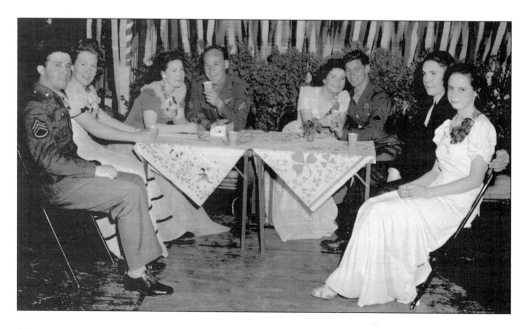

The women in this 1945 photograph are cadet wives who would volunteer at the Cadet Club. This was a service club for young men who were in training to become officers and pilots.

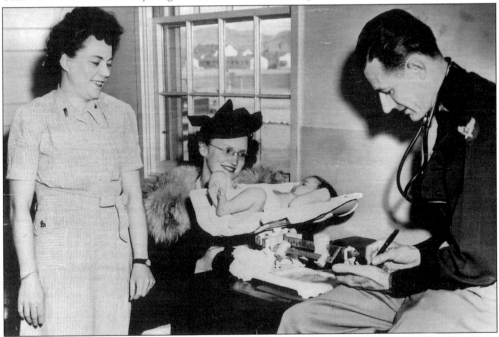

Linda Anne Schaner, the first baby born at the Kingman Army Air Field Hospital, has her three-month check-up in 1945. With her in the photograph are, from left to right, nurse Lt. Adele Miller, Mrs. Schaner (Linda's mother), and Cpt. J. F. Weeks.

On April 22, 1944, the Kingman Army Air Field was consolidated and redesignated Army Air Force Unit 3018. Col. Donald B. Phillips commanded this unit from June 15, 1944, to April 1, 1945. The training facility reached its zenith in efficiency under his command. He was the last commanding officer to oversee training of military personnel. From April 1, 1945, to February 25, 1946, the commanding officer changed four more times as the base was deactivated and shut down. On February 26, 1946, Kingman Army Air Field became Storage Depot 41.

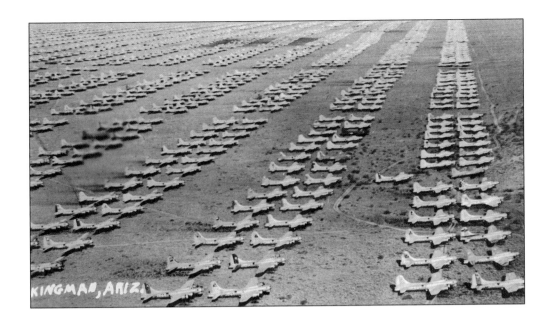

These 1946 photographs show lines of B-17s, both used and new, stored at Storage Depot 41. Most of the aircraft at the depot are B-17s. Storage Depot 41 was actually a graveyard, where military surplus planes would be dismantled and melted down for scrap. Kingman was one of five such sites. Depot 41 would temporarily house B-17, B-24, P-38, and A-26 aircraft. A few were sold to private buyers and museums, but most of the nearly 7,000 airplanes would be stripped of any salvageable materials and then chopped up and melted down into 70 million tons of aluminum ingots.

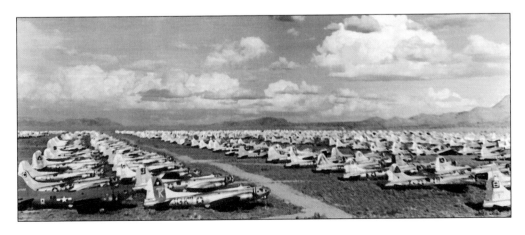

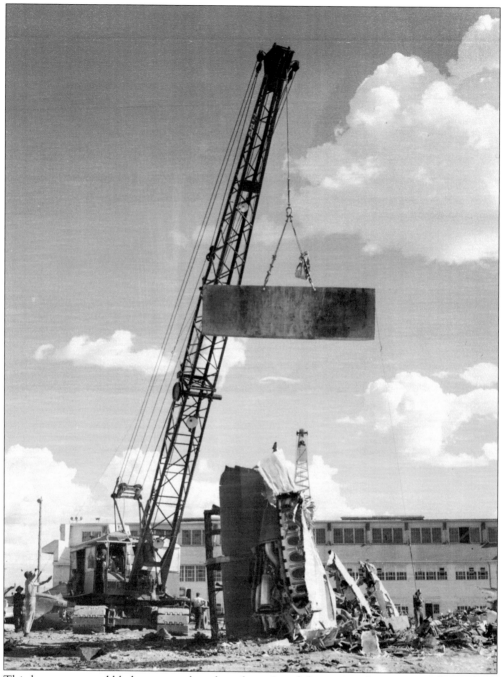

This large crane and blade were used to chop the stripped-down aircraft into pieces for smelting into ingots. This photograph is from around 1946 or 1947.

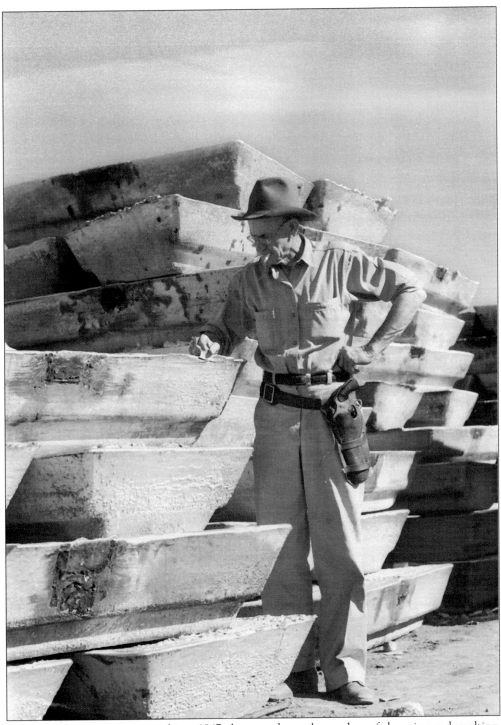

The large aluminum ingots in this *c*. 1947 photograph are the product of chopping and smelting. The armed man, presumed to be a security guard, is not identified.

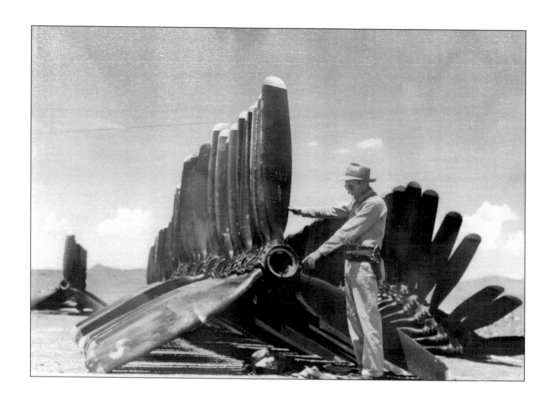

Other by-products of the process were propellers (above) and tires (below). Wires made of copper, silver, or gold were salvaged prior to the chopping and smelting, and local lore says that the contractor who got the job recovered his costs from just retrieving the fuel left in the aircraft when they were parked. Both photographs date from around 1947.

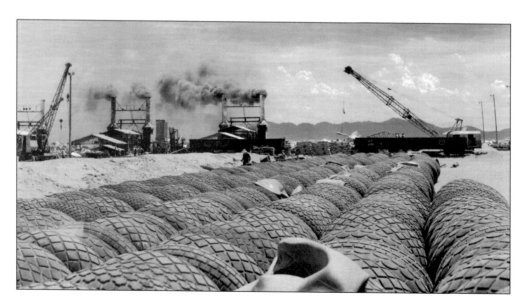

Seven

THE POLITICOS AND PROFESSIONALS

During Kingman's early years, the politically active and the professionals were many times one and the same. People of good character stepped up to serve, as they felt it was their duty to do so. That is not to say that power and influence did not play a part in the process then, as they did to some extent.

Businessmen, attorneys, cattlemen, and mine owners were the movers and shakers of the community and took the initiative on a regular basis to serve in public office. They did their best for community and county and helped shape the future for all who live in Kingman today.

William Hardy came to Mohave County in 1864 when it was first organized. He was the founder of Hardyville, builder of the Fort Mojave–Prescott Toll Road, elected to the council from Mohave County for the Second (1865), Third (1866), Fourth (1867), and 15th (1889) Territorial Legislatures. A staunch Republican in his politics, Hardy became a resident of Kingman in 1888, right after the county seat moved to the town, and spent the rest of his days here. He was involved in numerous enterprises during his 40 years as one of Mohave County's biggest promoters. His political career included postmaster, territorial councilman, justice of the peace, Mohave County supervisor for three terms, and candidate for Arizona delegate to Congress. He also served on several territorial commissions.

Oregon Demarcus McGintry Gaddis, a Republican, was elected to serve as a member of the House of the 18th Territorial Legislature in 1895. He was a resident of Kingman, moving there in 1891. He first worked as a bookkeeper in the Beecher and Company store and eventually opened and operated a mercantile establishment with John E. Perry. In later years, Gaddis became involved in mining and ranching. He was ever active in community affairs and served as clerk of the district court and as the postmaster at Kingman for many years.

Although Lawrence Oscar Cowan was a resident of Kingman and Mohave County for only about 12 years, he distinguished himself by much public service, which speaks well of his abilities and his popularity. He came to Kingman in or about 1886 and served as clerk of the district court, superintendent of county schools, and probate judge. Judge Cowan had the misfortune of losing part of his thumb as he set out to shoot a large cat. He apparently closed the breech of his gun on his thumb while trying to load a cartridge. The cat survived. Cowan also served Mohave County in the House of the Ninth Arizona Territorial Legislature in 1897.

Coming to Kingman in 1892, Kean St. Charles became editor of *Our Mineral Wealth*, a Kingman newspaper. St. Charles was an active individual who made many prospecting trips and mine visits into the mineralized areas of Mohave County. His reports on the mining activities in the county provide some of the best data and information on the local mining operations of the time. A Democrat, he served in the houses of representatives in the 21st and 22nd Territorial Legislatures in 1901 and 1903. St. Charles was then elected to the council of the 25th Territorial Legislature in 1909. He would go on to serve in the state senate of the Sixth, Seventh, Ninth, and 11th Arizona state legislatures.

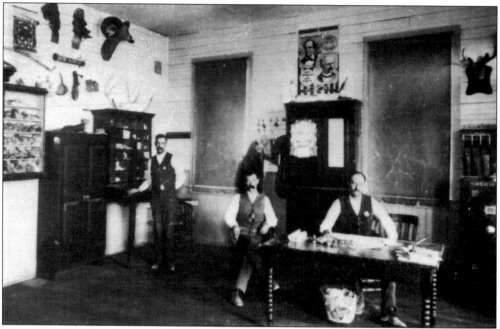

This is the sheriff's office around 1902, with Sheriff Henry Lovin (right) behind the desk with his Chief Deputy Walter Brown (center). The deputy on the far left is not identified.

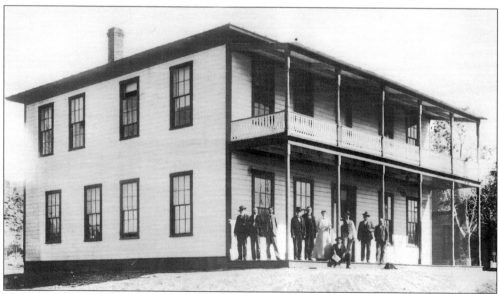

From 1890 to 1915, this was the first permanent courthouse in Kingman. The three individuals identified in this *c.* 1908 (or earlier) photograph are J. S. Logan (fourth from left), Judge William Blakley (fifth from left), and Marie Carrow (sixth from left), clerk of the board of supervisors.

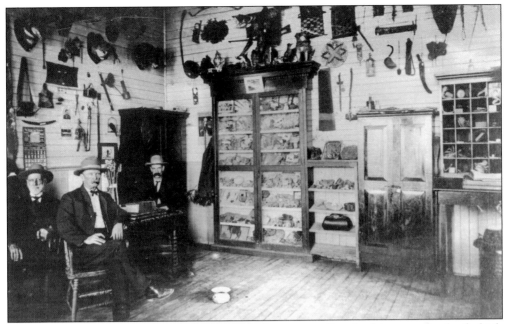

By around 1912, the sheriff's office had gained a lot more wall and cabinet art, much of which was confiscated evidence. In this picture are, from left to right, J. S. Logan, probate judge and superintendent of schools; J. P. Gideon, deputy sheriff; and Walter Brown, sheriff.

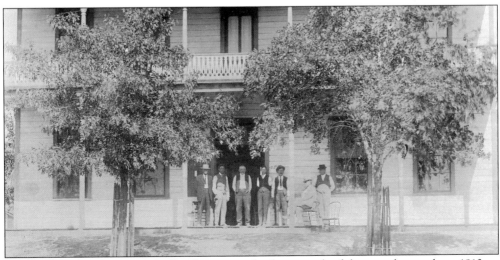

Newly elected and appointed officials pose on the front porch of the courthouse about 1913.

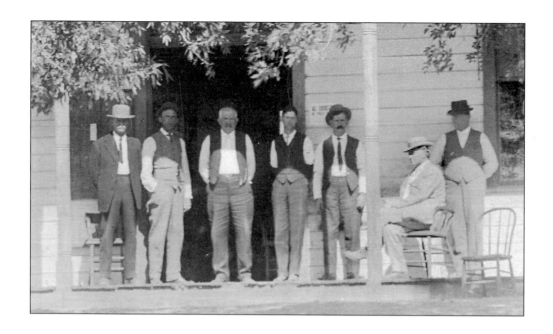

In this closes-up of the courthouse around 1913 (above), the following officials are identified. They are, from left to right, J. P. Gideon, sheriff; J. Barthalmew, clerk of the board; J. W. Morgan, recorder; I. J. Whitney, deputy recorder; J. C. Lane, under-sheriff; L. M. Teale, clerk of the superior court; and Thomas Devine, treasurer. At a gathering in the sheriff's office in 1913 (below) are, from left to right, J. C. Potts, Jack Lane, Asa Harris, J. P. Gideon, Tom Devine, unidentified, J. W. Morgan, Jack Porter, Lon Teale, and Charles Metcalfe.

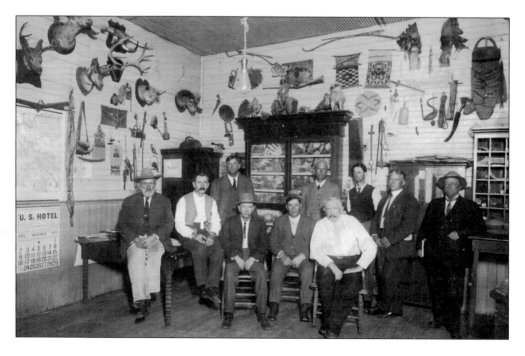

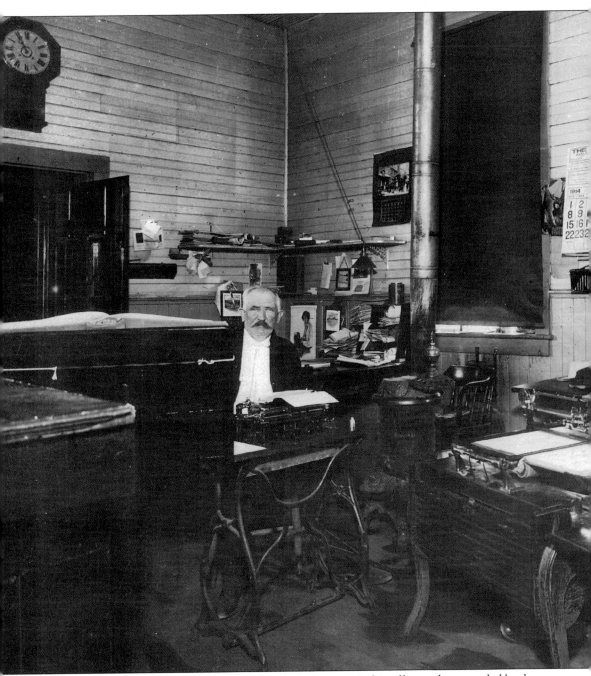

In 1914, county recorder Joe Morgan is sitting at a typewriter in his office and surrounded by the tools of his post. One of the large books for recording information sits on the cabinet top behind his right shoulder. Directly behind him is a desk piled with stacks of folders and papers. On the right is a machine that appears to be some type of copying or printing apparatus. It also has one of the large recorder books lying on it.

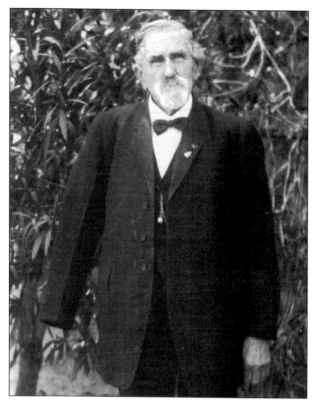

One of the best-known names in the legal profession in Mohave County was William G. Blakely, minister, attorney, judge, educator, politician, and civic leader. Both Blakely and the county seat came to reside in Kingman in 1887. Blakely's oratory abilities were said to be well honed as he was also an ordained Methodist minister. During his long life in Mohave County, he would serve as an attorney for the Atchison, Topeka and Santa Fe Railway; district attorney; superintendent of schools; judge of the Mohave County court; and probate judge. At the age of 78, the judge would serve in the council of the 24th Arizona Territorial Legislature in 1907. He was chosen in a special election to replace Patrick F. "Patsy" Collins, who had passed away. Blakely was a Republican, "clear through," in all of his political dealings.

Henry Lovin came to Kingman in 1893 and was a true American success story: starting with nothing and making a success of his life through hard work. He formed the Lovin and Withers Mercantile in 1900, grubstaked a prospector who discovered one of the largest gold strikes in Mohave County and Arizona, started numerous businesses, operated a ranch, and served his community politically in numerous ways. A Democrat in politics, he was once a constable, twice-elected county sheriff, chosen to represent Mohave County in the Arizona constitutional convention, and was elected twice as the first state senator from the county. After that, he served as a county supervisor from 1925 until his death in 1931.

William P. Mahoney, a Democrat, originally came to Mohave County in 1902. After a short absence, he returned in 1909. Elected to the second and third sessions of the Arizona legislature, he served with distinction first in the state house and then in the state senate. After two sessions in the state capital, he returned to Kingman and was elected county sheriff for two terms. His service as sheriff was extraordinary and would require several more pages to recount. Following his turn as sheriff, Mahoney became an agent for the Santa Fe Railway. His son, William P. Mahoney Jr., would become an ambassador to Ghana under Pres. John F. Kennedy.

Herb Kemp Biddulph had come to Arizona in the 1930s and to Kingman after World War II. He lived here for 14 years. He was a partner with Roy Dunton in an automobile dealership and a strong proponent of incorporation for Kingman. When Kingman formed as a city in 1952, Biddulph was elected its first mayor. He served from 1952 to 1955. Shortly thereafter, he moved to the Phoenix area and continued his involvement in automobile dealerships.

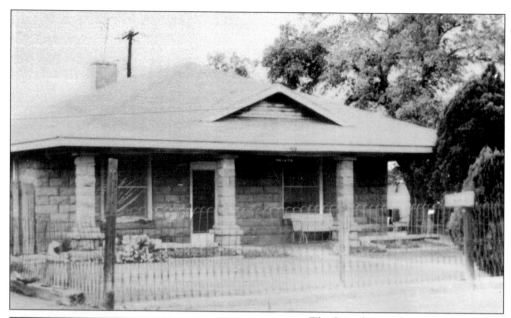

The Lacy home above, shown here around 1970, was used as the private Gully Hospital in 1916.

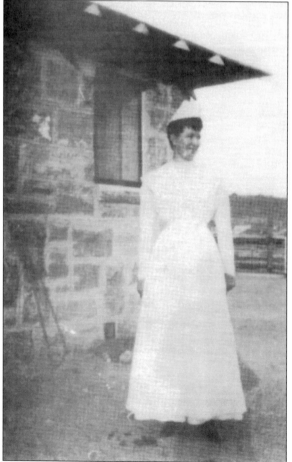

In 1916, Minnie Gully, a professionally trained nurse, opened a small private hospital in Kingman. The house was owned by O. E. Walker and leased by Gully. It could serve only a few patients at any given time but was a welcome addition to the medical services community. Since most care was still provided in the home at the time, the little hospital at 906 Madison Street filled a gap in the medical care provided in Kingman.

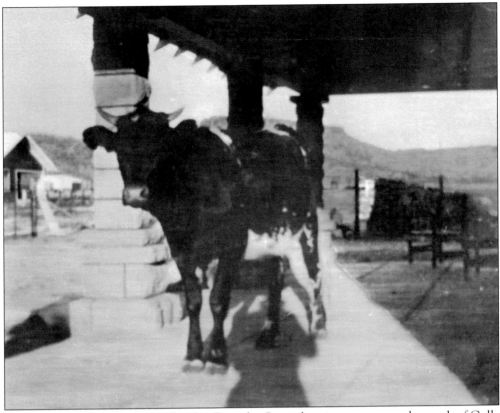

A popular Kingman resident in her day, Rose the Cow takes time to pose on the porch of Gully Hospital in 1916.

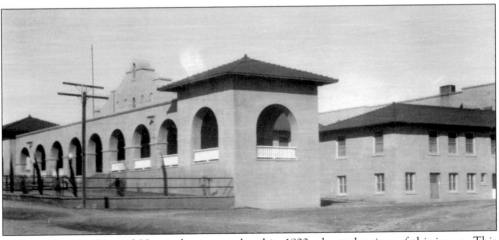

Mohave County General Hospital was completed in 1922, about the time of this image. This beautiful Spanish Revival architecture would grace the north side of Beale Street between Grandview and First Streets until 2008, when it had to be torn down. It also served as the sheriff's offices in its later years.

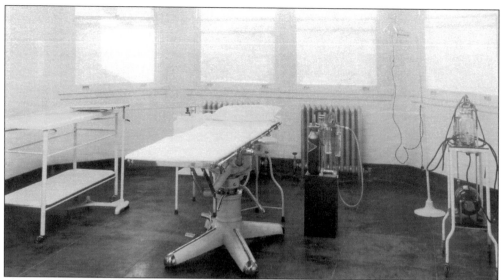

This *c.* 1930 examination room at the hospital seems very bare bones when compared to such rooms today.

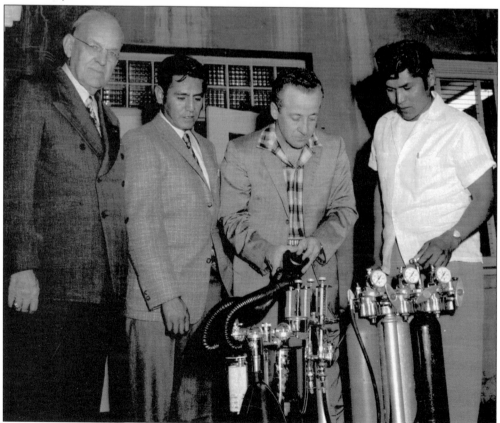

Around 1950, Dr. Francis Findley (far left) and Dr. Arthur Arnold (third from left) inspect new respiratory equipment that is now available to the hospital. The other two gentlemen in the photograph are not identified.

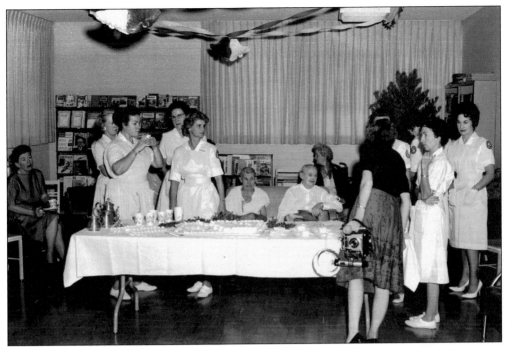

In this *c.* 1950 photograph, the Pink Ladies volunteer group hosts a party for two patients at Mohave General Hospital.

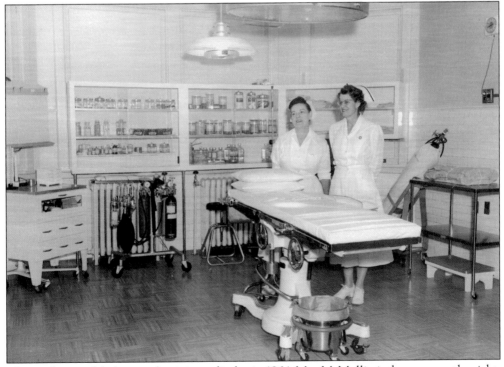

The newly remodeled surgical unit is on display in 1964. Mae McMullin is the nurse on the right; the other nurse is unidentified.

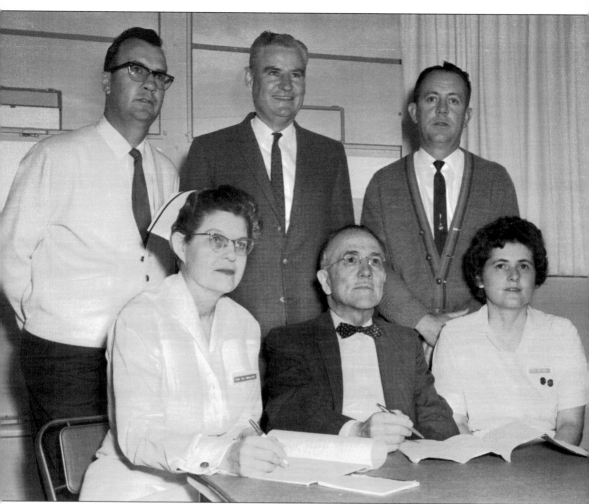

Representatives from various facets of the community meet to help publicize the 1963 blood drive. The following are, from left to right: (first row) Mae McMullin, RN; Walter Brazie, MD; and Helen Graves; (second row) Roy Dunton; John L. Ashe, Ed.D.; and Charley McCarthy. Roy Dunton, a businessman and civic leader, represented the business community. John L. Ashe, Ed.D., an educator, represented the school district. Charles "Charlie'" McCarthy, mayor of Kingman, represented the city. Mae McMullin, RN, director of nursing at Mohave General Hospital, represented the hospital. Walter Brazie, MD, was representing the local chapter of the American Red Cross. Helen Graves, a volunteer with the Pink Ladies, represented that group.

Eight

HOMES AND PEOPLE

While is not possible to provide a complete photographic history of all of the homes and people that inhabit any town, those in this chapter are representative of the thousands of families that have made up Kingman over the years. The unique and wonderful images here include those of families mentioned in other sections of this book plus additional homesteads and citizens from Kingman's history.

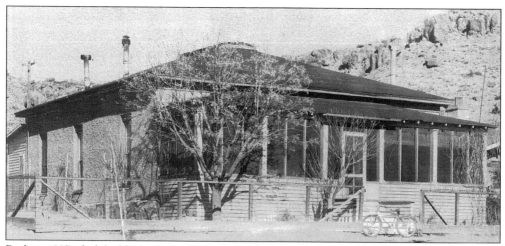

Built in 1897 of adobe blocks, Judge William G. Blakley's home is located on the northeast corner of Fifth and Spring Streets. The porch was added in 1920. It is one of the oldest continuously occupied homes in Kingman. This photograph dates from about 1929.

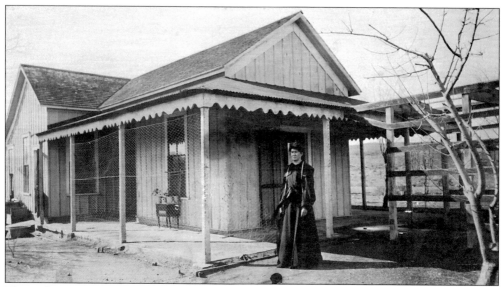

This is the George Bowers home as it looked around 1894. The chicken wire attached to the porch posts allowed flowering vines to grow up and shade the house in the summer. The unidentified woman may be Delfina Bowers.

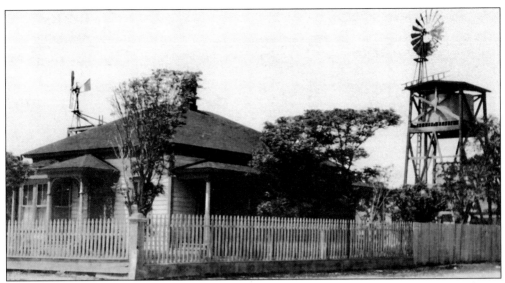

The Gustavus W. Beecher home in this photograph from around 1900 was located on the northwest corner of Fifth and Front Streets. Beecher was a local businessman and Civil War veteran. His son, Summer H. Beecher, married May I. Devine, the sister of Andrew "Andy" Devine.

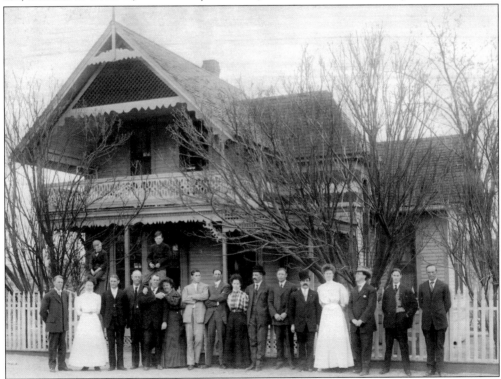

The J. W. Emerson home was located at Fifth and South Front Streets. Emerson was an undertaker. This photograph is from around 1900 and the people identified are Alta Hubbs (second from left), Greely Clack (fifth from left), Gertrude Potts (ninth from left), Steve Haskins (twelfth from left), Mattie Blakely (thirteenth from left), and Ed Shaw (fourteenth from left). The boys on the fence are Ted (left) and Ernest Blakely. The reason for the gathering is not recorded.

Seen here around 1890, the H. H. Watkins home was located on the northwest corner of Fourth and Beale Streets. Watkins was the pharmacist who owned and operated Kingman Drug.

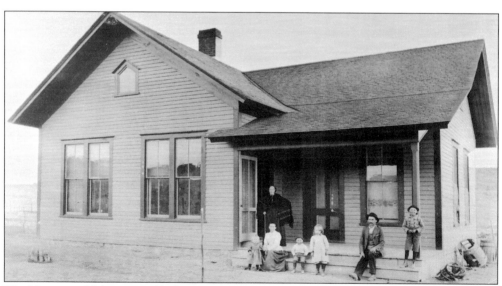

The Harvey and Johanna Hubbs home is located on the corner of Fourth and Golconda Streets and today is the centerpiece of a small city park on the south side of downtown Kingman. This c. 1891 photograph shows Grandma Wilkinson in the doorway and, from left to right, Vernon Hubbs; his mother, Johanna Wilkinson Hubbs; Wayne Hubbs; Alta Hubbs; his father, Harvey Hubbs; and Louis Wilkinson, son of Chris Wilkinson and nephew of Harvey and Johanna.

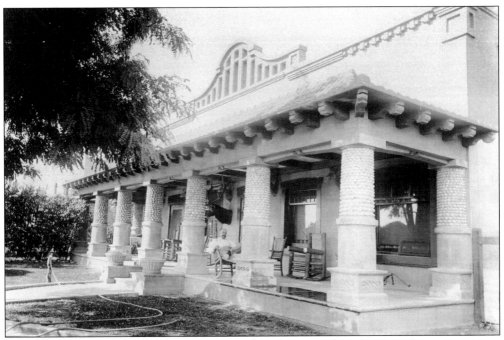

Henry Lovin is shown relaxing on the porch of his home. Built in 1897, the house fronted on Beale Street, and Lovin's property ran to the northwest corner on Sixth Street.

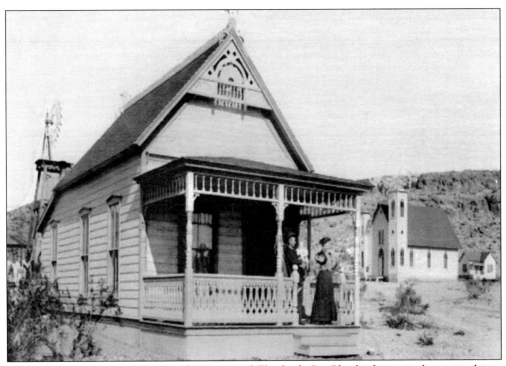

Located at 400 East Oak Street, the Kean and Elizabeth St. Charles home is shown in this c. 1898 photograph. On the porch are Kean St. Charles and his daughter, Irene, and wife, Elizabeth Oram St. Charles.

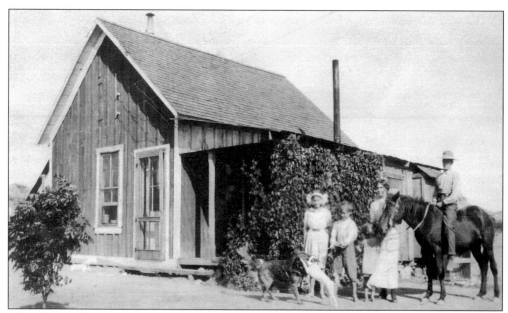

The John "Red" and Della Harris family poses outside their home in this *c.* 1890 photograph. Della's maiden name was Gross, and she was from Mineral Park. This house was located near the corner of Gold and Grandview Streets.

The Joseph and Theresa Kause home still stands at the corner of Second and Beale Streets. In this *c.* 1910 image, Theresa Kause (left) poses on the porch with her three daughters—from left to right, Frances, Mary and Annie. Frances would marry Frank L. Porter, who would become Mohave County sheriff. Frank died in office in 1960, and Frances was appointed to complete his term, becoming the first and only woman to serve in that role. She died at age 91 in the same room of this house in which she was born.

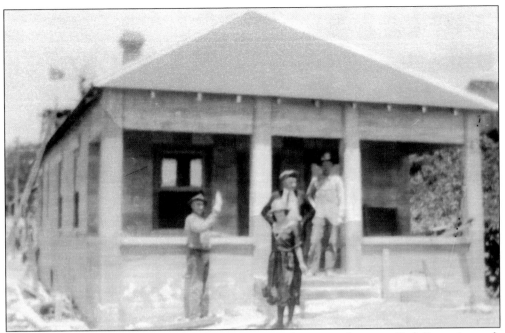

The Clack brothers are building this distinctive poured concrete home on Park Street in south Kingman in 1917. They did not live in the house but built it for resale. It still serves as a private residence today.

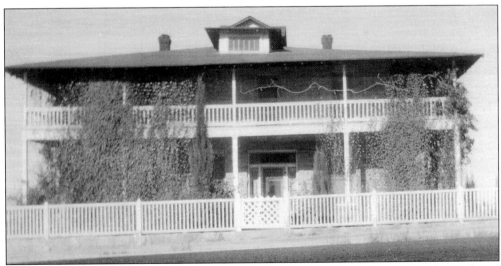

Seen here around 1935, the residence of George and Effie Tarr Bonelli is located on the southwest corner of Fifth and Spring Streets. This was their second home at the same location; an earlier wooden house was destroyed by fire. This structure was built of stone in 1915. Today, it is a museum that showcases daily life in Kingman in the early 1900s.

This is the John and Amy Neal home, located at 419 Topeka Street, as it appeared around 1942. The Neals were pioneer ranchers and, as was the custom, they had a residence in town as well as at their ranch. The couple in front is Inez and Glenn Kell.

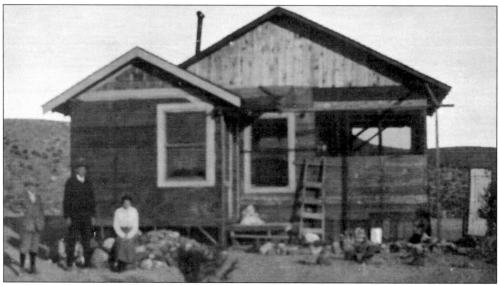

Longtime resident and businessman Glenn Johnson (left) began his stay in Kingman in this modest home on Grandview Street. He is shown here in 1916 with his father and mother.

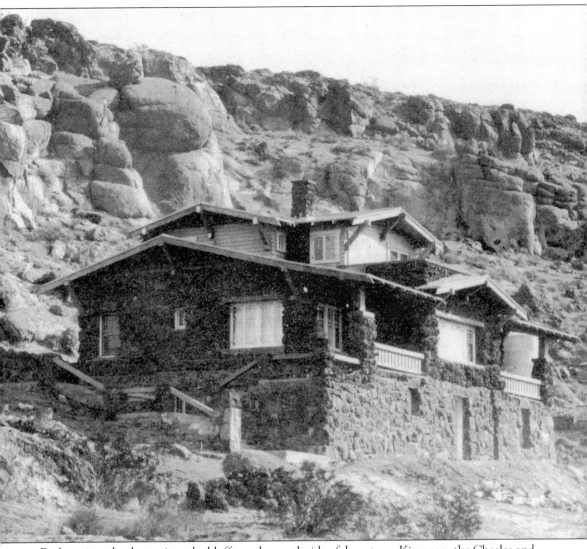

Built against the dramatic rocky bluffs on the north side of downtown Kingman, the Charles and Josephine Van Marter home used local materials to blend into its surroundings. It is located on Pine Street between Fifth and Sixth Streets. Van Marter came to Mohave County from Grass Valley, California, settled at Chloride in 1898, and moved to Kingman in 1900. He owned shoe shops in both Chloride and Kingman. In 1903, Van Marter purchased an undertaking business and renamed it Van Marter Mortuary. He remained in that business until his death in 1935.

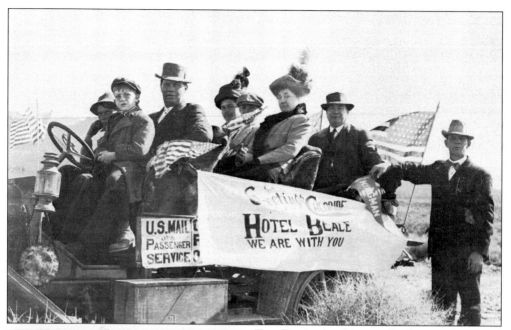

Tom Devine has his son, Andrew, on his lap at the wheel of this open car in a parade at Chloride, Arizona, around 1912.

Born in Flagstaff, Arizona, in 1905, Andrew Devine moved with his family to Kingman in November 1906, when his father, Thomas, purchased the Hotel Beale. Andrew was known as a likable-yet-mischievous boy throughout his childhood. He played football and basketball for Kingman High School. Later he played football for Santa Clara University and spent one year in professional football with the Los Angeles Angels in 1925. In 1927, he began appearing in silent films but quickly moved to talkies and made a name for himself with his unmistakable raspy, squeaky voice. He appeared with John Wayne in several movies, including 1939's *Stagecoach*. Andy Devine passed away in California in 1977.

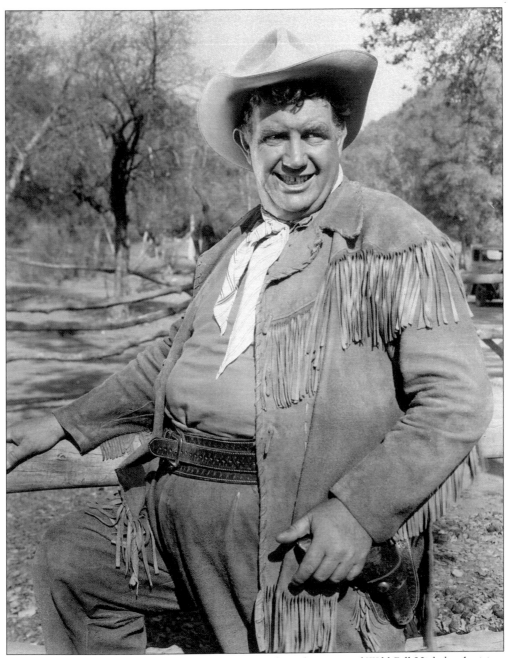

Andy Devine poses in his Jingles costume from *The Adventures of Wild Bill Hickok* television series that starred Guy Madison. In 1955, in an episode of the television series *This is Your Life*, he was presented with the honors of having Front Street renamed Andy Devine Avenue and the creation of an annual Andy Devine Days Parade, which continues to the present.

DISCOVER THOUSANDS OF LOCAL HISTORY BOOKS FEATURING MILLIONS OF VINTAGE IMAGES

Arcadia Publishing, the leading local history publisher in the United States, is committed to making history accessible and meaningful through publishing books that celebrate and preserve the heritage of America's people and places.

Find more books like this at
www.arcadiapublishing.com

Search for your hometown history, your old stomping grounds, and even your favorite sports team.

MADE IN THE